RIVER CALDER

ROGER FROST, IAN THOMPSON
& VICTORIA DEWHURST

Supported by
The National Lottery®
through the Heritage Lottery Fund

heritage
lottery fund

AMBERLEY PUBLISHING

Preface

This book was suggested by many of those who heard Roger Frost's illustrated talk, 'Lancashire's Calderdale', given over a number of years to local groups in the Lancashire area. The talk relied on the illustrations that appeared in the Revd T. Ormerod's 1906 publication *Calderdale*, many of which were made into overhead slides by the late Mr Ken Bolton. Miss Jessica Lofthouse's charming book, *The Three Rivers*, which was published in 1946 and dedicated 'to the North Country lads for whom the Three Rivers Country was the England worth fighting for', has provided much of the inspiration.

Roger Frost is the author of this book and he accepts that, if there are any mistakes in the text he is entirely responsible. Roger has written the book as a native of the valley of the Lancashire Calder and he makes reference to what the river and its tributaries mean to him. Ian Thompson has taken almost all the modern photographs, and Victoria Dewhurst has been the environmental consultant.

The authors would like to acknowledge the contribution of the Ribble Rivers Trust, which has invested Heritage Lottery Funds in the environmental projects carried out in recent years on the Calder and mentioned in the book. They would also like to thank publisher Joe Pettican from Amberley Publishing for his encouragement, patience and understanding.

Roger Frost

First published 2014

Amberley Publishing
The Hill, Stroud, Gloucestershire, GL5 4EP
www.amberley-books.com

Copyright © Roger Frost, Ian Thompson and Victoria Dewhurst, 2014

The right of Roger Frost, Ian Thompson and Victoria Dewhurst to be identified as the Authors of this work has been asserted in accordance with the Copyrights, Designs and Patents Act 1988.

ISBN 978 1 4456 1892 0 (print)
ISBN 978 1 4456 1904 0 (ebook)

British Library Cataloguing in Publication Data.
A catalogue record for this book is available from the British Library.

Typesetting by Amberley Publishing.
Printed in Great Britain.

Contents

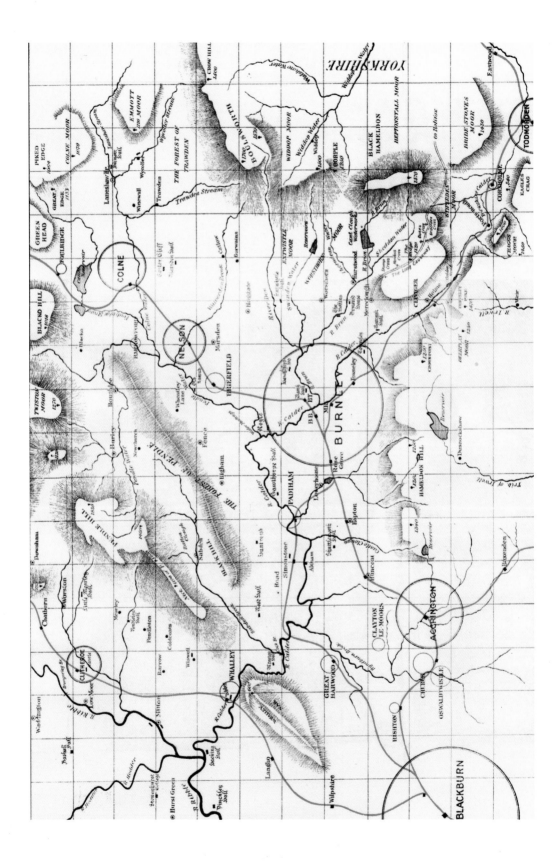

Introduction

A cool but atmospheric afternoon was preceded by an overnight fall of rain. The latter had not amounted to the deluge that is often the case during autumn in the Pennine hills, but there had been enough to more than dampen the well-trodden footpaths of the Valley of the Goblins.

Richard Jefferies, the great Victorian nature writer, tells of his visits to a hill. The walk to it was three miles, he said, and the effort in getting there cleared his blood of the heaviness accumulated at home.

> The familiar everyday scene was soon out of sight; I came to other trees, meadows and fields; I began to breathe a new air and to have a fresher aspiration. I restrained my soul till I reached the sward of the hill; psyche, the soul that longed to be loose.

The location of Jefferies' hill was in his native Wiltshire, but many of us have its equivalent. Mine is a wooden stile, recently renewed by the body of which I was the chairman, halfway up a hill, the top of which commands views of the surrounding countryside.

My little spot, a natural grassy platform on the sunny side of a tumbledown, gritstone wall, is within hearing distance of a stream which, when it becomes a river, is the shortest in England. Today, as there is the gentlest of breezes, the sound of the water is magnified by the recent rain. Occasionally, the bleating of a distant sheep and the bark of a faraway farm dog can be heard. At this quiet time of the year, there are still birds, though sightings are few and their song is tired. The rude awakenings of a grouse is the only sign that reveals its presence.

To get here, after parking my car, I walked the best part of a mile past familiar features like the ruined inn where old Miles Hardcastle brewed his own 'whist', refreshing General Scarlett and his friends when, several lifetimes ago, they were enjoying the hunt. Then there is the line of collapsed limekilns, fewer now the stream has advanced. As a boy I played 'king of the castle' on these mounds of cold earth that once burned brightly as the locally hushed lime was burned to be put to use on the nearby farms.

Nearing the bridge over the stream and passing the remains of the stepping stones, I come to the site where the water engineers drilled to find out whether it would be possible to build Robin Hood's Reservoir here. Thankfully, nothing came of their endeavours. The valley was not flooded and I can still enjoy this wondrous place. I reach my little platform by way of the steep and slippery path, where a farmer on horseback fell and was killed. He was returning to Worsthorne from the Piece Hall in Halifax by way of a shortcut. Perhaps it was such a day as this, when even a well-walked footpath can be transformed by rain into dangerous rivulets of sparkling water?

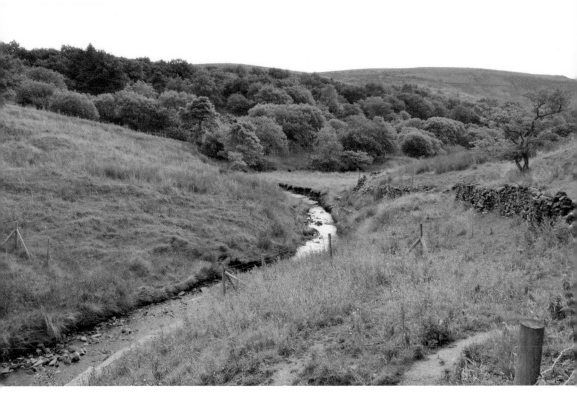

Thursden, the Valley of the Goblins.

I am greeted, as always, by the great oak tree, this year heavy with acorns. I asked if I could take a few of the little seed-bearing cups and grow them on so that the tree's beauty could be shared in generations to come and others could be as fortunate as I have been these past fifty years. This reminds me of something that I did quite often, at this very spot, when I was a young boy: the planting of acorns and young self-seeded whips in the little treeless plot of land in front of me. None of them grew, of course. The sheep saw to that, but I did not understand how destructive these seemingly innocent animals could be.

Similarly, I did not realise what was the purpose of this woodland and why it had been planted in the first place. General Scarlett knew and the coverts he used can still be seen. When shooting was taking place, the solitude of the Valley of the Goblins, the peace that I was searching for, was utterly destroyed merely because some gentlemen wanted a bit of sport.

A helicopter is flying overhead. It crosses my vision at a great height and disappears into the gathering mists of Pendleside. The sound is soon absorbed and quiet returns. Reassuringly, from my little platform, the views are the same as I have always known them. Dark, especially in this sunless weather, the distant church spire reveals itself, though four of the mill chimneys that once accompanied it have long since gone as the age of King Cotton came to an end.

But what of the Valley of the Goblins? It is not like the place of the same name in the desert state of Utah in America. It could not be more different. It is my private valley and, though I don't own it, or any piece of it, I regard it as such. I never tire of the valley. It is full of interest at all times of the year and in all seasons.

Thursden, looking towards Red Spar.

Some say that the ancients, many of whose resting places are but a stone's throw away, believed that Thor lived here and created thunder by banging his great hammer against the rocks below Rieve Edge. Another more likely derivation refers to the thurses that, it has been said, once lived in Thursden. A thurse is another word for a goblin, a wicked, supernatural creature better understood as a poltergeist, the creator of chaos and wreaker of destruction. There is little evidence of either chaos or destruction in my little valley. On a day such as this, heavy with cloud and the threat of descending mist, Thursden can be a dark and uncompromising place, but it does not frighten me. Perhaps it should.

The Valley of the Goblins is typical of the valley of the Lancashire Calder. Superficially, Thursden is merely a green and wooded area crossed by challenging paths and is a great place for a walk. However, search a little deeper, accept the challenge to understand and, like Richard Jefferies, allow yourself to feel a little more, and many a place is transformed beyond what is immediately evident.

Another writer, Jessica Lofthouse, who as a teenager I met quite often, wrote of the Calder:

> But this is the Calder, the poor Cinderella of the three rivers meeting in Mitton demesne, a somewhat tarnished beauty since industry took possession of her valley.

The other rivers are the Ribble and the Hodder, known nationally for their salmon and trout fishing. Until recently, if the Calder was fished, it was by local men, generations of

Steeped in history, the head of the Thursden Valley features many historic sites.

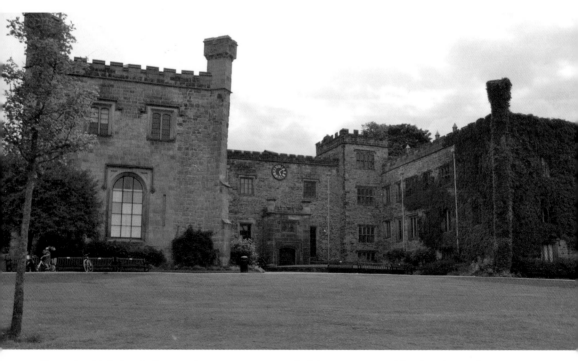

Towneley Hall Art Gallery and Museum, surrounded by acres of parkland and woodland, is a 'must-see'.

whom needed no licence because there was a much held opinion that 'there were no fish in t' Calder'. An extension of this wisdom, when I was a boy, went something like this: 'you won't get trees to grow on the barren Burnley moors'. These prophets of doom have been proved wrong by the success of the Forest of Burnley Project, which planted 1,200,000 trees, mostly in our moorland cloughs.

The fish are coming back to the Calder and its tributaries. Abandoned coal mines are no longer allowed to discharge into local streams, which, as result, are cleaner and oxygenated, allowing numerous species to thrive where once they had little chance of establishing themselves. Added to this, the sponsors of this book, the Ribble Rivers Trust, are engaged in a number of projects aimed at improving the waters of the many rivers of Lancashire's Calderdale. It is only now that their work is being recognised not only for what has been achieved but also for its potential for the future. In this book, the work of the Ribble Rivers Trust will be outlined as we make our way down the Calder and its tributaries from Calderhead to Great Mitton, where our story ends.

Similar things are happening on our local ponds, and especially on the length of the Leeds & Liverpool Canal. There was a time when youths with air rifles would shoot at the odd duck or swan that mistakenly found its way to our stilled waters. Now, at the appropriate time of the year, there are swans every three-quarters of a mile or so along the canal, and there are so many ducks at Towneley Park in Burnley that the authorities there have displayed notices asking people not to feed them.

At the splendid Victoria Park in Nelson, it would be true to say that there are so many ducks, swans and coots apparently in residence that they too are becoming a problem. The locals and the many visitors to both parks love the birds, and the only criticism one hears of Towneley is that the peacocks and peahens of the past have not been restored to their rightful domain.

Towneley Park's lake is only a short walk from the banks of the Calder, which once formed the boundary between Towneley's farmed land and its park. Now the former is largely a well-maintained municipal golf course and playing fields. Some of the Old Park, with its newly restored Deer Pond, is still parkland, though it is a modern park and not the hunting park of the past. In Nelson, Victoria Park is divided into two entities by Pendle Water, which interestingly has also been known as the Calder.

A map of 1786, surveyed by William Yates, clearly names the river at Holme End as the 'River Calder'. The Calder of this book is another stream and it rises east of Cliviger at a place once known as Calderhead. There is, of course, the much bigger Yorkshire Calder that, historically, rose within a few yards of its Lancashire namesake. To distinguish between them, these rivers were once known as the West Calder, the river of this book, and the East Calder, the river that flows in the direction of Todmorden and eventually to the east coast.

The other Lancashire Calder, the one named on the 1786 map at Holme End, is really Pendle Water. It is shown on modern maps as such, though locals will insist that it is the proper Lancashire Calder. They argue, and they are right, that it is a more substantial river. They claim that their river has a larger catchment area, and they are right in this too, but two great authorities disagree.

The first is William Harrison (1535–93) who, though he was a Londoner, had local connections with Lancashire's Calderdale being educated at the Westminster School of Dean Alexander Nowell, who we will meet in these pages. Harrison's great work, *Description of England*, is still in print. It was published in 1577 as part of Holinshed's Chronicles, the book William Shakespeare allegedly used when writing his historical plays. Harrison is important to us because, in writing about the West Calder, he says that it '... riseth above Holme Church', a reference not to Holme End but to Holme Chapel in Cliviger.

William Camden (1551–1623) in his *Britannia*, which was published in 1586, also identifies the West Calder by indicating that it 'goeth by Burneley'. The two authorities have it that the Lancashire Calder is the river that we know as 'the Calder', and it is to river that we must return.

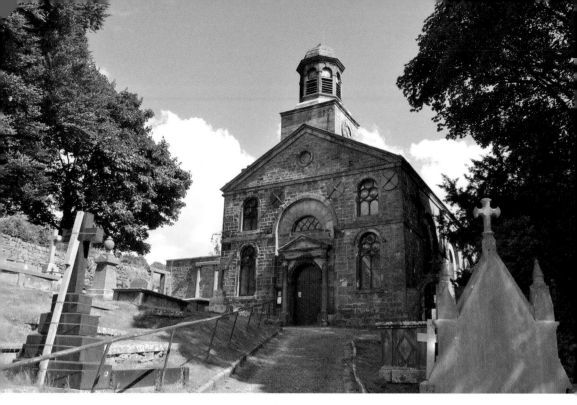

Holme Chapel, now the parish church of St John the Divine.

It would be amiss not to speculate about the origin of the name of the river. Much has been written about this subject, but it can be summarised as follows. For many years the explanation outlined by Ekwall held sway. He mentions three rivers of that name. The one to which we refer, he accurately describes as a tributary of the Ribble. The others he mentions are the Calder, which flows out of Ennerdale to Seascale on the coast of Cumbria, and the north Lancashire Calder, which is a tributary of the Lancashire Wyre. Ekwall points to words in Welsh that, when the syllables are combined, mean 'hard, violent water or stream'. David Mills added 'rapid', and this makes the picture complete.

The Lancashire Calder, the river of Lancashire's Calderdale, is not the languid river it becomes beyond Mitton when the Ribble takes over. Something similar can be said of the Yorkshire Calder as it outgrows its turbulent origins and approaches the relatively flat plains of that county.

There are, however, parts of our Calder that display the features described by both Ekwall and Mills. One of the better examples can be seen as the river enters Towneley Park in Burnley. Quite suddenly, the river, though it does not actually foam, picks up speed as its waters dash among the rocks of the riverbed. This has been attributed to the 'canalisation' of the river by the Towneley family when they were in residence in their beautiful hall.

Of course, the river was not canalised for commercial navigation. The work was done to speed it up as it passed by the ancient park. Over the years, there has been many a flood in this area and lower down the river near Burnley, and this still happens today in really bad weather. The wise old heads of Fulledge may be proved right one day as Unity College and its grounds are swept in the direction of Parliament Street.

However, they will not be able to blame me because as mayor I exercised my casting vote against a proposal to sell the land necessary for the building of the college to the county council. The Lancashire County Council appealed and the secretary of state had the temerity to disagree with the Queen's representative in Burnley. The secretary of state got his way, but the mayor wanted to preserve the integrity of the 600-year-old park.

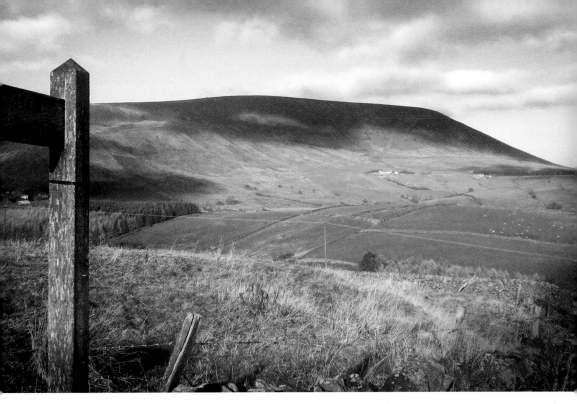

The brooding hill that dominates the East Lancashire skyline, Pendle Hill.

The name Calder essentially means 'fast-flowing water' and, even if the characteristics of the waters as they enter Towneley Park have been modified, there are many other stretches of water where the phenomenon they describe can be observed, and these have not been subjected to the works of man.

The waters of the Calder can be dangerous. This is because when the river is in spate, the result of sudden and heavy rainfall, it quickly gathers unexpected momentum and becomes a danger to anyone or anything in its path. The Calder Valley has one of the highest rainfalls in England, which is to some extent the product of the critical position of Pendle Hill that dominates the whole of our area.

There is a saying about Pendle, my version of which is 'When you cannot see the top of Pendle it is raining. When you can, it is about to rain!' We can see the spectacular part of Pendle – its famous Big End. On the other side of the hill, they don't have the splendid view but neither do they have the rain.

Pendle is a bit like Black Combe on the Cumbrian coast between Millom and Seascale, in that it can be raining metaphoric cats and dogs on the Combe, but on either side of it the sun will be out and the temperatures good. On the promontory itself, which is not exactly treeless, very little grows, but at Becermet, a few miles north of the Black Combe, there have been palm trees in the village for as long as I can remember.

The rainfall around Pendle might not be quite as dramatic as it is at Black Combe, but rain we certainly have! This, when combined with much of the clayey nature of the Lancashire Calder, affects many aspects of the lives of people who live nearby. The clays are glacial in origin. They are difficult to plough and, until the invention of tarmac and despite the best endeavours of a legion of road builders (and a local bridge master), the clays were responsible for some of the worst and most dangerous roads in England.

The presence of the impenetrable clays had such a bad affect on the agriculture of Lancashire's Calderdale that its wealth had to be sought underground. Coal, and in vast quantities, has been

mined in what has been termed the 'Burnley Coal Field', though it stretches far beyond the limits of the town. The use of coal in the textile mills, the foundries and the machine shops of Lancashire's Calderdale, together with the pollution of the mining of coal itself, transformed the area, making it, as Miss Lofthouse wrote, the 'Cinderella of the Three Rivers'.

Jessica comments, 'A hundred years has done its worst; will a hundred more see the Calder the clear stream of two centuries ago?' She then refers to Edwin Waugh's *Pictorial History of the County of Lancaster* (1844), who describes the Calder of his day as rising between Holme and Portsmouth, adding that he had 'no difficulty in discovering the site by the superior freshness of the greensward'.

'Looking towards Burnley we saw a number of interesting objects spread over a country gradually opening and sinking down to the plains.' These are also the words of Waugh. 'The vegetation was rich; the brook, whose head we had just passed, was here and there dammed up, making good pools for the angler and adding to the beauty of the country.' He then mentions Habergham Eaves where 'the scenery, yet remaining agreeable, has lost its mountainous character'. Next is the park at Towneley on the outskirts of Burnley and Burnley itself, which he describes as 'an important division of the parish of Whalley'. The town, he writes, stands 'on a tongue of land formed by the confluence of the Burn, or Brun, with the Calder'. The route to Padiham, Read and Whalley is outlined and, at the latter, the Calder is described as 'a sweet bubbling stream' flowing around the newly planted woods of the Nab. Getting her information from an old lady, Jessica then reminds us that some seventy years before the Calder was 'clean enough for a child to paddle in'.

We live in exciting times when the hopes of Jessica Lofthouse and the descriptions of Edwin Waugh are being realised by the likes of the Ribble Rivers Trust before our very eyes. This, together with the astonishing history and heritage of the Lancashire Calder, is to be our theme. It is time that Cinderella found her real place in the world.

1

Cliviger Gorgeous

'Cliviger, Gorgeous.'

I have often thought that if I were writing a book on Cliviger, which is to the east of Burnley, I would give it this title. For those of you new to this most attractive area, the Cliviger Gorge is a remarkable example of a glacial valley that follows a fault line cutting through a section of the Pennine hills.

The feature was explained to me by Charles Kelly, my geography teacher from school (who insisted on being called Ned, taking his cue from the helmet-wearing Australian bandit). The gorge was created at the end of the last Ice Age when glacial meltwater, together with unimagined quantities of ice, forced its way though a weak point in the towering Pennines.

Unlikely as it may seem, this meltwater came from Lake Accrington, a glacial lake of which, to me at least, there was no evidence on the ground. The creation of the gorge happened about 15,000 years ago. Even Sherlock Holmes would have had difficulty proving this, I thought, but the truth is that the Cliviger Gorge was, at one time, the most famous of its kind in the world. Geology, you see, like landscape gardening, has British origins and this, one of the most dramatic gorges in England, could be visited quite easily by early geologists, who included the feature in their books.

At a later date, after the passing of the Ten Hours Act and the coming of the railways that gave access to the countryside to even the most landlocked of artisans, local amateurs interested in botany, geology and geomorphology travelled to see the great gorge, its steep cliffs and its hanging valleys. Some of these valleys, severed from their parent rock by glacial activity, are adorned with what were then considered to be spectacular waterfalls, like the one in Green's Clough. Of course, slightly more impressive water features have since been discovered on certain rivers in Africa and North America. They put Green's Clough in its place, but people still came and they still do.

Cliviger is a delightful parish. The name, first recorded in the twelfth century, is Old English in origin and means 'land cultivated by a slope'. It is one of the places where the parochial name is not shared by its villages and communities. They include Holme Chapel, which has already been introduced, Walk Mill, Overtown and Mereclough, though I suppose that we should also mention Deerplay. Though not a village, Deerplay deserves a mention partly because its name derives from the hunting that took place throughout the Calder Valley in the Middle Ages.

Until 1895, Cliviger was much larger than it is at present. In that year, upon the creation of the Borough of Todmorden, the villages of Cornholme and Portsmouth were taken from Cliviger, the county boundary moved and these places were included in Todmorden, where they have been

Cliviger Gorge, where the Calder has its source.

ever since. Some say that before 1895, Cliviger was the largest civil parish in England, but that is no longer the case, if it ever was. England's smallest historic parishes are in the south of the country, where the majority of the population lived in medieval times and before. The further north, the lower the population, the larger the parish and England's largest parishes are in the north-east.

That being said, the civil parish of Cliviger, at over 6,700 acres, is big by almost anyone's standards, but it has not always been a parish. In days gone by, parishes were defined in ecclesiastical terms and Cliviger was part of the chapelry of Burnley within the great parish of Whalley, which included most of north-east Lancashire and the Forest of Bowland. In fact, an alternative name for this book, had it been written two centuries ago, might have been *A Journey Through the Parish of Whalley*. Whalley was just about the largest ecclesiastical parish in England, something that was recognised by a Cliviger man, the founder, if anyone was, of local history as an academic rather than antiquarian subject. I refer to Revd Dr Thomas Dunham Whitaker LLD, FSA, the author of *The History of the Original Parish of Whalley and Honour of Clitheroe*, which covers a huge area of the county. We will be meeting him regularly in this book.

We are in Cliviger because it is here that the Lancashire Calder starts its short but fascinating journey to Great Mitton, west of Whalley, where it joins the mighty Ribble. The actual site of where the river has its origins is described by the Revd T. Ormerod, the author of *Calderdale: A Descriptive Account of the Streams Forming the Lancashire Calder* (1906). The site is at Calderhead where Mr Ormerod is within a few yards of both the Calders, the Lancashire and the Yorkshire rivers of that name. He writes, 'Here, from a small shallow pond whose surface is covered with weeds and fringed with bulrushes we find our stream emerging.'

There is more detail.

> On tracing the stream to its actual source, we find it trickling from a tiny cleft in the rock on the hillside opposite the Pointman's Cabin, falling in sparkling drops amongst the bracken and debris into a little cavity in the earth … (not much bigger than a bucket),

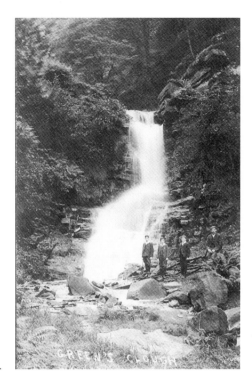

Green's Clough, Cliviger.

from which it emerges in an underground passage, marked only 'by the greener green of the greenery' and steadily gaining in force and volume until it becomes a clearly defined rill as broad as one's wrist.

Of course this is a description of the source of the river written over a century ago and this little plot has changed in that time. Open-cast mining high above the site and the activities of a local farmer who, having found the water dangerous to his lambs, covered it over, have had their effects. However, I am not sure the claims of travellers on the railway that the site could be seen from the line as passengers trundled to Burnley or Todmorden were ever quite true.

Jessica Lofthouse knew that Cliviger Grange was once close by; this was run as a large sheep farm by the monks of Kirkstall Abbey near Leeds in Yorkshire. Until recently, its site had been forgotten. The modern historian of Cliviger, the late Mr Titus Thornber, once had it at the foot of Ratten Clough, following the logic that it must have been associated with Monkhouse Rake, an ancient track that climbs from here via Green's Clough and over to Rochdale. Since then, following the work of Dr Frank Stansfield, Mr Thornber found evidence that the Grange was situated on a natural platform at the top of the rake. Incidentally, a 'rake' is an old word for a footpath in these parts.

A short walk away from the source of the river, the remains of three fishponds can be found. One of the ponds has been beautifully restored by Todmorden Anglers. When they applied to Burnley Council for funding over twenty years ago, I was pleased to vote the sum of £15,000 to support the scheme, and has that amount ever been better spent? What has been created is an oasis of calm within a few yards of the busy Burnley to Todmorden road. It is not only visited by anglers but was designed to be part of a lovely, relatively level walk that finishes at the Ram Inn, Cliviger's favourite watering hole.

The walk is, to some extent, the recreation of the vision of Dr Whitaker, the historian, and his grandson, Thomas Hordern Whitaker, who planned and executed a circuit of Holme Woods. It

was completed in the mid-nineteenth century and Dr Whitaker claimed that it was five miles in length. Mr Thornber describes it thus:

> The walk became of such interest that, up to its decay in the 1930s, parties from near and far were made to arrive at Holme Station and then be conducted round the circuit.

It was designed for the residents of the Holme, where the Whitaker family lived, but the project included some pretty radical thinking: a small building that housed a water turbine, powered from one of the ponds, generated electricity that supplied not only the Holme but also the church and the Ram Inn. The walk also included a visit to the still spectacular waterfall at Green's Clough and there was a lonely dogs' cemetery, complete with little gravestones marked with the names of the younger Mr Whitaker's bulldogs. There are several tunnels on the route bearing the initials of their builder. One of them has 'THW' and the date 1850.

Perhaps the most interesting features of this walk were the three fishponds buried, as Mr Thornber describes, within glorious woodlands:

> The centre pond had a fishing shelter built on an artificial island, perilously approached over stepping stones, like some Highland Castle. A rowing boat was chained to a convenient tree trunk. The pathway went up one side of the stream, which was the infant Calder, crossed over the dam of the middle pond, and then returned down the other side to cross over the pack-horse ginnel in Royd Wood by a wooden bridge.

This walk extended in the direction to the far side of the valley and linked the railway station at Holme, Buckleys, and the steep sides of Dodbottom Clough. There was even a dark tunnel hacked through tough rhododendrons, a feature found in other Victorian pleasure grounds, where gentlemen were able to steal a kiss with their favoured young lady in complete privacy! The 20-foot-high waterfall of Black Clough, above what Mr Thornber described as the 'rather fearsome depths of the Black Clough stream', is also included.

Sadly, much of the Whitaker's pleasure grounds are now overgrown, its bridges collapsed to such an extent that parts are now impenetrable. There is, however, still the easy circuit of the remaining fishpond, and refreshments at the Ram Inn, only a short distance away.

You will not be surprised to learn that this large site, made possible by the purchase of land off other owners, was not always given over to leisure. Remember that we are in Lancashire – industrial Lancashire – where manufacturing is never very far away, even though it might have been lost in the mists of time. Such a case is to be found by the waters of the 'infant Calder', where two significant industrial activities have been carried out. It has been known for some time that Cliviger has extensive deposits of both iron and lead. The former was mined at Riddle Scout in the Middle Ages (the name itself comes from the iron workings), though it was not known where the ore was processed. Similarly, the site of lead workings, near Thieveley, has been documented and the site of a lead smelting mill on the banks of the Calder has been noted.

In fact, the story of the lead industry of Cliviger is told in a novel by Titus Thornber, called *King Charles' Mine*. It tells of the small part played in Cliviger in Charles I's attempt to make himself independent of the power of Parliament. To achieve this, he had to make as much from his own estates as he could. The royal estates extended to Lancashire, as Charles was the successor to Henry IV, heir to John of Gaunt, Duke of Lancaster. Immediately before the English Civil War (1642–49), the King encouraged the mining and smelting of lead on his possessions in Cliviger. The site of the lead smelt mill was known as being situated beneath the dam of the Whitaker's bottom fishpond. However, when the site of the mill became available for examination in 1988, a significant archaeological discovery was made.

Mr Thornber asked Mr Eric Greenwood, who had been appointed instructor to an employment training dry stone walling team and given the task of restoring a packhorse ginnel, to look for

evidence of a lead mill. This was known to be close to the site of the ginnel but, after some heavy work in difficult terrain, Mr Greenwood announced that he had discovered the slag heap of an ironworks. 'No, Eric,' said Mr Thornber, 'it was a lead works.' But Mr Greenwood and his colleague, Mr Ron Redfern, were right. Even though the discovery was reported in the local newspaper, on BBC Radio Lancashire and on television as the remains of an old lead smelting mill, the examination of the slag revealed that it was not composed of lead at all, but of iron.

This was a revelation. No one suspected that there had been a pre-industrial blast furnace in this part of the world, though perhaps they should because there are several place names associated with the iron industry nearby. As they were not recognised, the surprise was much the greater once the discovery was revealed. The furnace was operational in the early eighteenth century and was the subject of a book written by Mr Thornber. When you visit this spot, try to imagine what this very pleasant, even picturesque, location must have been like with a furnace on site!

We leave the anglers content at their beautiful fishpond for the interesting little village of Holme Chapel, noticing the lovely cottage at Berril's Green on the way. The village is but a stride away. In some ways it appears to be a typical English village; a manor house, a church on rising ground with its lovely and much visited graveyard, a village school, two public houses, both still doing good trade, and a number of mostly stone-built houses, some of which date back to the handloom era.

Holme is the village in which my grandfather settled when he arrived in Burnley from Luton, by way of Nottingham, in 1923. He came to a foreman's job at Greenhalghe's, Burnley's leading dyers and dry cleaners, and he brought his young family, including my father, to live at the rented former vicarage. My father, who was nine years of age when he arrived, attended the village school opposite the house and he had very pleasant memories of living in the quiet village.

The Holme is, or was, the big house. It is now merely a shell, the result of a fire some years ago but, hopefully, it can be restored. The Holme was a lovely house on an ancient site. The name means 'island' in the language of the Vikings, and there may have been a house on this site at that time. Such properties would not have been built of stone but of the timber with which Cliviger abounds. It would have been chosen for residential use because the site was a little higher than much of the surrounding land, and therefore less prone to flooding in the undrained days of the distant past.

The building was the home of the Whitakers of Holme for centuries. Even in the days of my grandfather, the family was still in residence in the person of a Lt-Col. Macnamara, who had married into the family. Robert Frost, my grandfather, told the story of an incident that took place soon after his arrival in the village. He walked to the Holme to pay his rent but found that, once in the grounds, his way was barred by a fearsome dog. Grandfather, a Sherwood Forester who fought and was injured in the First World War, was the kind of man who did not bow to anyone or anything, especially a dog. The animal was threatening to do him an injury, so he thought quickly about what a Lt-Col. of the militia might call his dog. 'Down Captain,' he shouted, in as military a way as he could muster. The dog obeyed and grandfather met the astounded military man and paid his rent.

It is, of course, with Dr Thomas Dunham Whitaker that the house is most associated. He inherited the estate unexpectedly in the 1780s, but it was in poor order. Dr Whitaker was a clergyman who also found himself in possession of his own broken-down, sixteenth-century chapel in the village. In addition, work was needed at the house and the young man resolved to make the improvements that his inadequate income would allow. It took him some years but he planted his estate with 480,000 trees, winning in the process the gold medal of the Royal Society of Arts. He also rebuilt the chapel, now the parish church, and made improvements at the house. It was Dr Whitaker's tree-planting schemes that inspired the Forest of Burnley Project.

There is a story about Dr Whitaker's trees that is worth the telling. Like all good men, when elderly he made preparations for his own passing. He called to his man and asked to be placed

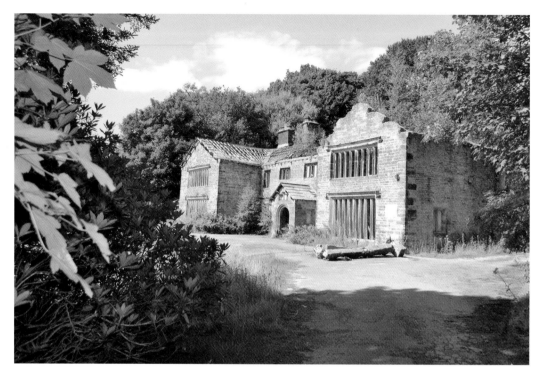

The ruins of the Holme.

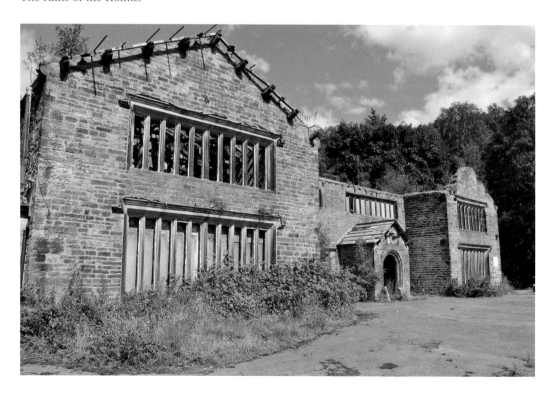

on a simple stretcher and be carried into the woodland he had planted years before. He guided his men to a particular tree, one of his favourite larches, pointed to it and ordered that it be cut down and fashioned into a coffin for his own use. When Dr Whitaker died in 1821, he was buried in a coffin made from a tree of his own planting.

The church that exists today is the one built at the time when the French Revolution was at its height, largely at Dr Whitaker's expense. He was a fierce opponent of any form of radicalism, as is clear not only from his writings but also in his activities as a leading magistrate. He did, though, choose what must have been regarded as a modern design for his Anglican church. The building looks more like a Nonconformist chapel than the typical tower and spire Church of England church. However, the building was erected at a time when the churches had not yet decided that Anglicans should have Gothic buildings and Nonconformists should have Classical structures.

There is another Anglican church in Blackburn built in the same style and at a similar time to this one in Cliviger. They are the only two in the Blackburn Diocese and both are dedicated to St John, the church in Cliviger to St John the Divine and the one in Blackburn to St John the Evangelist. The link may well be Dr Whitaker because he not only served his own church in Cliviger but was also vicar of Whalley, Heysham and Blackburn.

At St John's in Cliviger, something that is not often seen in many of our local churchyards is a fairly common sight: there are visitors to the churchyard who do not come to tend the graves of loved ones, but to see the monuments raised to the dead. Possibly the most interesting grave here is that of General Sir James Yorke Scarlett of the Fifth Royal Dragoons. He lies close to the west door and his memory is still honoured by a service held on the Sunday nearest the Battle of Balaclava. It was at Balaclava that he made his name in the victorious Charge of the Heavy Brigade, which took place on 25 October 1854.

Sir James was related by marriage to the Thursbys of Ormerod, Burnley's biggest employers of the nineteenth and early twentieth centuries. Members of the family, including the founder of their dynasty, the Revd William Thursby, lie close to the remains of Sir James. In the lower part of the churchyard, there is a lovely stone memorial to Alice Mary Towneley, 1st Baroness O'Hagan, who was the last member of the Towneley family to live at Towneley Hall. Lastly, there is the gravestone of Jerry (Jeremiah) Dawson. A local man, he was one of Burnley FC's greatest goalkeepers and a model citizen of which any area would be proud.

It is a pity that there is no marker to the last resting place of Henry Wood, who was interred in the churchyard in 1729. Henry was a member of the Whitaker family who was recommended to Sir Christopher Wren for employment by Richard Towneley of Towneley and, from 1688 to 1702, Henry was a clerk of works in the rebuilding of St Paul's Cathedral in London. He is remembered by the annual Wood Sermon, which is preached at St John's a month before Christmas.

Though he has many achievements to his name, it is as a historian that Dr Whitaker is remembered. It is not too much to say that he was the founder of the academic study of local history. Before him, antiquarians had delved into the stories of local families not from the historical perspective but to show that ancestors came from good blood, were arms bearing and were worthy of their exalted situations in society. Dr Whitaker changed all that. Though he acknowledges the work carried out before him by the 'Great Transcriber', the antiquarian Christopher Towneley of Carr, he actually did proper research, visited the sites he was writing about and consulted authorities. The result is that, though his published material contains the prejudices of a country clergyman, and an opinionated one at that, his books remain the starting point for much of the local history of the lands drained by the Lancashire Calder.

There is, in Towneley Park in Burnley, a religious cross saved for posterity by the actions of Dr Whitaker and his friend Charles Towneley, the great collector of Classical art, much of which is now in the British Museum. The reference is to the so-called Foldys Cross, which will be 500 years old in 2020. It is the gravestone to John del Folds, a chantry priest at Burnley's church of St Peter. In 1789, the year of the French Revolution, Dr Whitaker and Mr Towneley had the

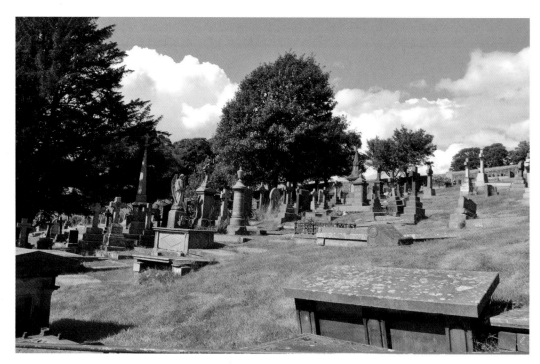

The churchyard at St John's.

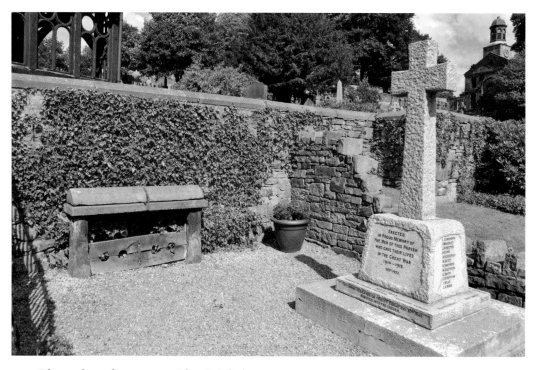

The stocks and war memorial at St John's.

cross removed to the safekeeping of Towneley Park. The cross had been damaged in a drunken brawl and was removed to a site directly behind the hall. Though not in its original position, the cross remains in the park to this day and is one of the lesser but much appreciated glories of Towneley.

When in Holme, it would be remiss not to mention its long closed railway station. It was one of Dr Beeching's many victims, but the line – the direct route from Burnley to Manchester – never actually closed. It remained open for goods traffic until it was given a new lease of life when the old Burnley Building Society was merged with a Bradford rival some thirty years ago. Reopening the line to passenger traffic made sense and the line is now being restored, the tunnel refurbished and the call to reopen what was a typical rural station is being increasingly heard in the pages of the local press and Burnley's council chamber. The campaign was led by a former mayor of Burnley, Councillor David Hegginbotham. Now the missing piece of the jigsaw, the Todmorden Curve, as it is known, is being restored and trains from Burnley will soon be able to travel directly to Manchester rather than go by Accrington, Blackburn and Bolton, a ridiculously long and inconvenient route.

The Calder passes near the site of the former station, and it will be noticed that it is no longer the tiny stream of the fishponds. It is not a raging torrent, at least it is not today, but it would take a better athlete than me to leap over the stream. Little is left of Holme station itself, but it was the site of a tragic railway crash in September 1907 when the coal wagons from a runaway goods train became detached from a down train at Copy Summit. The ticket collector, Mr William Pim, was killed instantly as the wagons ploughed through the little station.

It is now time to leave the village of Holme and head in the direction of Burnley, noting the mature woodlands of the Cliviger Valley. This part of Burnley is the most intensely wooded part of the present borough. It is the direct consequence of the work of the two friends Dr Whitaker and Charles Towneley, the latter responsible for much of the planting in this part of the valley that was included in the Towneley Estate.

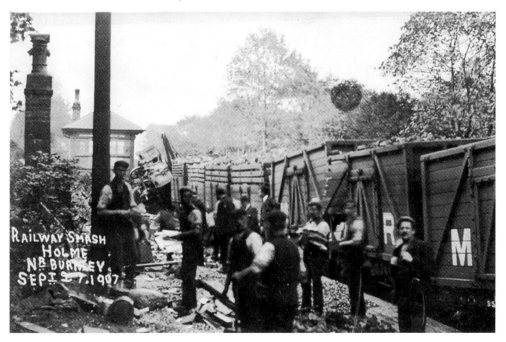

Railway smash, Holme, near Burnley.

However, before we reach Burnley, we must consider another of Cliviger's villages, if only for its name. The village to which I refer is Walk Mill. It is relatively rare for a residential community to be named after an industrial process, but this is how Walk Mill got its name. The process referred to is fulling – the cleansing of woollen cloth after it is woven – and from early times it was carried out by people who literally walked the often heavy cloth in large wood-lined vats sunk into the ground. The local vats were filled with water from the Calder, to which human urine was added, collected and paid for by the fuller at perhaps a penny an earthenware pot, though female urine was worth more! I need not tell you what phrase has come down to us from this, but you might not know that the process is responsible for the surname Walker.

I recall in my teaching days being asked by my thirteen-year-old pupils what their surnames meant. When I devoted a lesson to the subject, I tackled the list alphabetically, concerned that Steven Walker might be embarrassed. Of course, I need not have worried. I had told the class that my surname could mean that my ancestor may have been a frosty, unpleasant character. A few of the more sharp-witted youngsters said that they could understand that! But Steven was an intelligent boy and I had nothing to worry about. He even gloried in the information about his surname.

Walk Mill has an interesting industrial history. It was a mining village and many of the miners' cottages remain, now beautifully cared for and making attractive homes. There are still little reminders of the coal industry such as the staithes where coal was loaded on to delivery carts and the site of mineral railways. There is still a small fulling mill, now not used as such, but the corn mill, the brewery and the icehouse have all gone, lost to a sizeable housing development.

We are now on the edge of Broad Ing, part of the Towneley Estate, and the Calder will shortly enter the great park and the town of Burnley. As you will discover, we commence with the beauty of Towneley but we are introduced to the parts of the Lancashire Calder that made it, as Jessica Lofthouse put it, the Cinderella of the Three Rivers.

2

The Cinderella of the Three Rivers

The Calder rushes into Towneley Park as if it has great expectations and, as we will find out, its hopes are fully realised. Though in early spellings of the name, as with many other rivers, there is reference to water, the word Calder reveals the nature of the river, its violence and rapidity. My preference is for 'fast-flowing stream' and, when the river enters Towneley Park after rainfall, its waters live up to this description.

It is worth pointing out that the Calder does not follow its natural course here, which has been altered to encourage the river to flow through the park in an attempt to overcome the flooding that still takes place. In the past, the lower part of the park formed a floodplain of the Calder and, occasionally, this is confirmed with vast quantities of water flooding the children's play area between the new Unity College and the Fulledge Recreation Ground, the gift of the Towneleys and the home of Burnley's Annual Fair.

But we are getting ahead of ourselves. I first want to take you to Towneley's walled garden. This facility once provided the family with fruit and vegetables for the table but now, unfortunately, it is divided into three sections. Burnley Council's Green Spaces Unit, which maintains the 250 acres of the park, keeps vehicles here. By the entrance, there is a tidy bowling green that, in happier days when local councils had more resources, hosted the annual bowling match between members of the council and their officials. I remember my father, a chief official who was not a crown green bowler, playing a game with a council member who clearly was. Dad was soundly beaten by the chairman of his own committee, but they shook hands knowing that they had a meeting the following week.

The third part of Towneley's walled garden is devoted to the Offshoots Permaculture Project, the leading example of its kind in the north of England. If you are thinking of looking up the word 'permaculture' in your dictionary, don't bother; the work is too new to have troubled many lexicographers.

The word was coined in the mid-1970s by two Australians – David Holmgren and Bill Mollison – to describe their design system pioneered as a response to what they saw as serious challenges to the survival of us all. Permaculture, a contraction of the words permanent and agriculture, looks at strategies to create sustainable communities and food growing methods that do not cost the earth. A good definition of permaculture is that it is 'about creating sustainable human habitats by following nature's patterns'. Its ethics are 'People Care, Earth Care and Fair Share'.

At the project, the visitor will find sustainable buildings, space for woodworking crafts, a blacksmith working in a sustainable way and a model backyard, which demonstrates that even

the smallest place can produce its own fruit, vegetables and herbs. There are also examples showing the production of solar and wind energy and the site contains a reed bed through which used water is directed to show that clean, useable water can be produced at the other end. You can even arrange to have your own beautiful yurt made here!

Offshoots, which is managed by Newground, is also known for its pioneering work with the British black bee. A colony of them was found on the Bolton Abbey Estate of the Duke of Devonshire and a breeding programme has since been established. It transpires that Burnley, because of its situation in the valley of the Lancashire Calder and surrounded as it is by hills, is an ideal place for this project to be based.

Recently, there has been a lot of concern about the gradual but relentless disappearance of our honey bee. What is not realised is that the commercially bred honey bee is an Italian import. The British black bee, more suited to our climate and more resistant to the disease-carrying varroa mite, may just be the answer and this work is being carried out by an expert team at Offshoots. And, by the way, the bees produce the most fantastic honey!

However, Offshoots is best known for its growing beds. The Walled Garden is an ideal location for this work and a wide variety of organic fruits, vegetables and herbs are produced and distributed to local restaurants and food outlets. Not many people know this, but Her Majesty the Queen owns a hotel and restaurant at Whitewell on the Royal Estate in the Forest of Bowland, and Offshoots has supplied it with fresh vegetables and fruit.

The Royal connections do not end with Her Majesty. Her son and heir, Charles, the Prince of Wales, has visited Offshoots and, from all accounts, was most impressed by what he saw.

I think I ought to point out that I am chairman of the project committee at Offshoots. It has been a great joy of recent years to be involved with the wonderful people who work there, whether paid or volunteers.

Next, let us visit Towneley Hall and its park, both of which are a source of great pride to the people of Burnley, whose affection for the building, its collections and its surroundings are well placed. T. T. Wilkinson, a master at Burnley Grammar School and one of Burnley's Victorian local historians, was of the opinion that Towneley could trace its origins to a castle, set at the top of nearby Castle Hill. He indicated that it dated from the turbulent reign of King Stephen (1135–54), but no evidence of this building has been found, though it is possible that something of a lesser nature might have been constructed there.

The house dates from about 1380, but the family came into possession of land in Tunleia in around 1200, when Roger de Lacy, Lord of Clitheroe, granted to Geoffrey, son of the Dean of Whalley, two oxgangs of property there. Geoffrey married Roger's daughter, Alice, and their second son, Henry, who was living in 1259, became known as Henry of Towneley. However, it was not from Henry that the line descended. His elder brother, also called Geoffrey, had inherited the office of Dean of Whalley and it was from him that the family trace their descent.

The Dean of Whalley was the hereditary owner of Whalley church. He managed its property, collected its tithes and nominated the priests who served the church and its many chapels. Roger de Lacy was the fifth of his family to hold the Honor of Clitheroe, which had first been granted by William I to Roger of Poitou, the third son of Roger of Montgomery, a cousin of the Conqueror. As the head of the de Lacys, Roger was in exalted company, a member of one of the most powerful families in England. He was a personal friend of King John, as was his son John. The latter, however, changed sides at Runnymede and joined the barons when the Magna Carta was signed. This John was made Earl of Lincoln in 1232, and he was the grandfather of Henry de Lacy, the great Earl of Lincoln, one of the most trusted lieutenants of Edward I.

So the Towneleys, on the female side, were de Lacys. The male line of the family died out in the mid-thirteenth century with the death of Nicholas, whose property was divided among his three sisters. The youngest of these was Cecilia, who had married John de la Legh of Hapton and Cliviger. Their children, Gilbert, Richard and Lawrence, were known variously as de la Legh, from their father, and de Towneley, from their mother. It is likely to have been Richard who started to

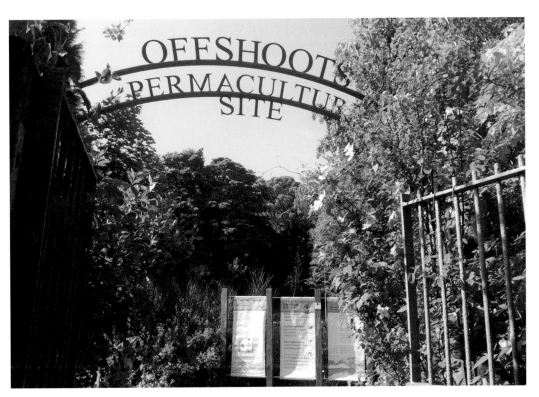

Offshoots Permaculture Site is an incredible community project that aims to promote and teach people the values of sustainable living.

build the hall, though another candidate was his son John, who died in 1399, the same year that the descendents of the de Lacy Earls of Lincoln became kings of England in the person of Henry IV.

The story of the building of Towneley Hall is very well told by W. John & Kit Smith in *An Architectural History of Towneley Hall, Burnley* (Heritage Trust for the North West, 2004), but the subtitle that they use is worthy of mention. In 1702, Ralph Thoresby summed up his impression of Towneley with the words, 'This college or castle-like house', which, in the first instance, is a reference to its then quadrangular plan and, in the second, to the crenellated towers housing the main stairs.

The castle-like appearance was enhanced in later years. Thoresby's college-like description of the building is explained because, across the front of the hall, there was a fourth range of buildings that contained, among other structures, the chapel and a gatehouse. When Thoresby visited Towneley, this range was still standing and, through the gatehouse, he would have entered a quadrangle not unlike those associated with the Oxford and Cambridge colleges.

Mention of the chapel is significant because, though the range of buildings was demolished not long after Thoresby's visit, the chapel still remains. It can be found in the hall itself and it is a most beautiful feature of Towneley. The chapel contains a wooden altar piece that was made in Antwerp between 1520 and 1525, though it was not acquired by Charles Towneley, the art expert, until around 1800. It left the hall at the end of the Victorian era and was installed in the convent of Notre Dame, Ashdown Park, East Sussex, but it was returned to Towneley in 1968.

The chapel also contains what, for many years, was the last resting place of the head of Colonel Francis Towneley (1708–46), the rebel Jacobite leader who was captured at the siege of Carlisle and hung, drawn and quartered in London, where his head was displayed on Temple Bar.

However, the most magnificent of the items on display in this part of the hall, and, to my mind, anywhere at Towneley, are the Whalley Abbey Vestments. It is said that they came to Towneley for safekeeping in 1536, after the failure of the Pilgrimage of Grace, the most significant of the rebellions against Henry VIII. Sir John Towneley (1473–1541), the builder of the chapel, is understood to have been responsible for bringing the vestments to Burnley. Being aware of his family's historic role in Whalley, where he was educated, he probably regarded the saving of the holy vestments as his duty.

The vestments, which have recently been restored by the North West Museums Service, include a chasuble, a maniple and one dalmatic, and they constitute the only surviving complete set of medieval English High Mass vestments. They date from 1390 to 1420 and are of Italian cloth of gold with a pattern of strawberries. The broad bands, known as orphreys, contain the finest English embroidery and display the Life of the Virgin.

Burnley Corporation managed to buy back the vestments in 1922 after they had been removed from the hall twenty years before. In 2005, when I was mayor of Burnley and my sister, Pauline, was mayoress, we asked if we could use a photographic reproduction of the nativity from the chasuble as my official Christmas card. I am pleased to be able to say that this was agreed, something which gave both of us great pleasure.

There are many other things to see in the hall, including a fine collection of pictures in the art gallery. These include the famous, and very valuable, *Charles Townley and His Friends in the Park Street Gallery, Westminster* by Johann Zoffany, which is often out on loan to other galleries across the world. In fact, as Burnley Council's executive member for leisure and culture, I was asked to agree the painting's loan to an exhibition being held, I think, in New York.

Of course, there are other paintings at Towneley, and the hall itself was the subject of a 1799 painting by J. M. W. Turner, which was intended for inclusion in Whitaker's *History of Whalley*. Turner, then a young man, was attracted to Burnley by the patronage of Charles Towneley. Joseph Farquharson's *The Sun had Closed the Winters Day*, a scene showing sheep and a shepherd trudging through heavy snow, is very well known because of its use on thousands of Christmas cards. Sir Lawrence Alma-Tadema's *The Picture Gallery* is also much appreciated, but my favourite is Frederick Daniel Hardy's *Early Sorrow*, a painting that shows children making arrangements for the burial of their pet bird while the guilty party, a cat, is hiding under some furniture.

Towneley has a splendid collection of regional seventeenth-century furniture, which is a testament to the work of the council officials who have been responsible for Towneley since Lady O'Hagan, the 'Last Resident' as she has been called, left the hall in 1902. When she did so, the hall was almost empty. The family had lived in the building for about 500 years, but very few of their possessions remained in the hall.

There are rooms dedicated to aspects of Burnley's history: an Old Burnley Room, a Military Room and the fascinating kitchen and dining rooms. Also, you will find a splendid local history museum situated in the former estate brewery that preserves something of the history of Burnley's industry and commerce. However, the most popular exhibit is unquestionably 'Bill', a Himalayan black bear brought to Burnley at the beginning of the twentieth century!

The last displays to which I will refer are those in the Towneley Room. The Towneleys remain active in the Burnley area where Sir Simon still lives. His late wife, Lady Mary, was very much involved in the local community and is, perhaps, best remembered for her work to improve facilities for riding. The Mary Towneley Loop on the Pennine Bridleway is named after her. Their daughter, Cosima, is an elected member of Burnley Council.

The Towneley family, despite being on the 'wrong' side in the Civil War and several Jacobite rebellions in the seventeenth and eighteenth centuries, has a distinguished history. It is impossible to mention them all, but the scientist Richard Towneley (1629–1707), whose work led to Boyle's Law, is a good place to start. Boyle himself referred, perhaps a little generously, to the law named after him as 'Mr Towneley's hypothesis'. There is a memorial to Richard Towneley on the wall of Towneley Hall, and another in St Peter's church in Burnley.

In the seventeenth and eighteenth centuries, Towneley Hall became the centre for a circle of northern scientists, known as the Towneley Group. Its leading members included Richard Towneley and his uncle, Christopher (1604–74), who was a significant link to Lancashire's pre-Civil War scientific scene, as well as being an important historian. At the time, there were similar groups in London, Oxford and Cambridge and in 1662, though the Towneley Group acted independently of other groups, the majority coalesced to form the Royal Society.

The work of the Towneley Group is not as well documented as it might be, possibly a consequence of the sale and dispersal of the Towneley Library in 1883. Richard Towneley, who was in part responsible for the creation of this once important but now lost library, is also known for his improvements to, and popularisation of, the micrometer and his meteorological measurements. The micrometer had been invented by William Gascoigne, who died in 1645 aged around thirty, but it was Richard Towneley who communicated the invention, including his improvements, to the Royal Society in 1666.

In the entrance hall of Towneley Hall, there is a reconstruction of one of a pair of clocks presented to the Royal Observatory at Greenwich by Sir Jonas Moore in 1676. Sir Jonas, who was born in Higham near Burnley in 1617, was the driving force behind the foundation of the Observatory, and the presentation of the clocks led to the use of Greenwich Mean Time (GMT) around the world. Christopher Towneley was probably responsible for Sir Jonas' education at Burnley Grammar School, and for sponsoring his place at university. Sir Jonas sought Richard's advice on numerous scientific subjects and he has a claim for a share not only for the design of the Observatory, but also for the establishment of GMT.

Charles Leigh in his *The Natural History of Lancashire, Cheshire and the Peak in Derbyshire* (1700) wrote, 'The World owes a great many Obligations to the great industry and knowledge of Richard Towneley of Towneley.'

The Towneleys were Catholics, often educated abroad. For many years, the law of the land did not allow them to publish books, to participate in the government of the country or attend its universities. Though Richard did become embroiled in the politics of the time, his contributions to learning meant that he was not penalised as much as many other Catholics.

However, this cannot be said for other members of the family, including John, who was Richard's great grandfather. There is a most informative painting, executed in 1601, on display in the Towneley Room in the hall. It shows John, his wife and his family at prayer, but it also catalogues the price that John had to pay for his beliefs. He was subjected to years of imprisonment and heavy fines, but this did not change his mind in matters relating to religion and, similarly, this kind of thing did not prevent the family from making their chapel a base for what they desired – a Catholic revival in England. The chapel was the only place of Catholic worship in the whole district for many years and, in the times of danger, the house had several priest holes, one of which survives and may be inspected by the visitor.

Even though the activities of the family were restricted, they still managed to produce the historian and transcriber Christopher Towneley (1604–74) and the collector of classical sculpture, Charles Towneley (1737–1805). The latter drew up plans for a sculpture gallery at Towneley. This was not built, but it would have been located to the rear of the hall and accessed from the Great Hall. It is there that we must leave Towneley Hall, and it is with some justification that we locals call the hall 'The Jewel in Burnley's Crown'. The 250-acre green flag park, with its fine walks, splendid 250-year-old avenue of trees, 500-year-old oak tree, icehouse, lake, woodlands and wilderness is much appreciated by everyone who visits. It is in the park that the town's moving war memorial is located in a position made more prominent by recent improvements. There is much to do for the sportsman including a municipal golf course, a pitch and putt course, three crown green bowling greens, tennis courts and sports fields.

We leave the park after following the Calder the length of Towneley Holmes at Hanbrig Castle, the old Burnley entrance to the park on Todmorden Road in town. As we do so, it is here that nature, though manicured by council gardeners and tree surgeons, meets the reality of industrial Burnley.

Charles Towneley planted this avenue of trees 250 years ago.

Hanbrig Castle is the name, in Lancashire dialect, of the building at the main entrance to Towneley Park. There are others at Causeway End and at the Barwise car park higher up Todmorden Road, and a fourth and a fifth in Cliviger. This one, however, is the best. It was commissioned by Charles Towneley and was built in 1796 to a design by John Nash and cost just over £687. It was intended that the residential part of the building be occupied by the Towneley agent Mr Thomas Forshaw. Unfortunately, despite the eminence of the architect, the property became derelict and has not survived in its entirety. It was demolished, in part, by Burnley Corporation. When built, the residential part of the structure, which was known as Handbridge House, had attractive views of the Calder. It was built at the time of the completion of the first part of the Leeds & Liverpool Canal in Burnley, and Mr Forshaw would have been able to see the construction of the Burnley Embankment, one of the seven wonders of the waterways, from the windows of his house.

The canal was the sign of things to come. When the canal company started building in 1770, there was no plan for it to serve Burnley, which was at the time regarded as an unimportant village. But by the 1790s, things had changed and Burnley had become an emergent centre of the textile industry. At this time, the Handbridge area, so-called because there was a footbridge over the Calder that had a handrail to steady pedestrians, was little more than farmland. Industry was on its way – a small coal mine (the first in Burnley to have a steam engine) had opened near the river and was doubtless coughing great quantities of smoke and steam into what had been a lovely riverside spot not many years before.

Before we leave Hanbrig, a few notes about the area in which it is situated may be of interest. To the east was Fulledge House, where Henry Blackmore, the owner of the mine, lived. The house gave its name, as Fulledge Road, to the early Todmorden Road, though another early name of Burnley Wood Road is also known. Near here was Burnley's first swimming pool. It was open

air and is shown on maps made in the early nineteenth century. Higher up the track towards the Causeway End entrance to the park was Burnley's first post-Reformation Catholic chapel, which was built in 1817. Higher up still was the little handloom hamlet near Huffling Hall, now lost, though the small hall itself has survived. Huffling Hall is a reminder that the term 'hall' does not always apply to grand buildings like Towneley; the term is descriptive of the English hall house, many of which are much smaller. The present road bridge at Handbridge is remarkable for the mason's marks that can be seen only from the riverbank.

By the mid-Victorian era, Parliament Street, almost opposite Hanbrig Castle, has become one of Burnley's more important industrial areas. A number of large cotton mills and engineering works had been built and the rural attractiveness of this part of Burnley had been lost. In May 1878, a riot broke out in Parliament Street at the mill of Mr John Kay. It was the consequence of a 10 per cent reduction of wages by many of the Burnley cotton masters.

Walter Bennett, Burnley's historian, describes it thus:

> The mob first marched to the Mechanics where they hurled threats at the members of the Exchange. Then, in great disorder, they proceeded to John Kay's mills in Rawlinson Street and Parliament Street and began to smash the windows; at 6.10pm the Town Clerk, whose face was cut by a stone thrown at him, read out the Riot Act in Springfield Road, and, as the crowd refused to disperse, the police began to use their batons to clear the streets and one or two people were injured; at 8pm the warehouse was set on fire but firemen were not allowed by the assembled crowds to approach it until, at 9.30pm, some 70 soldiers made their appearance on the scene. At 10pm the mob collected at (the nearby) Towneley Villa, the home of Mr Kay, and once more windows were broken.

The mob moved off to the Westgate area, some distance away. The following morning, a crowd of around 300 assembled at Kay's mills, but rain drove them away. Later in the day, there were 87 cavalry, 302 infantry, 130 regular police (many from Manchester) and 140 special constables on duty in the town. In Burnley, when we riot, we do not do things by halves!

The most noticeable thing about the Calder in this part of town, apart from the remains of the mills and the surviving houses of those who worked in them, is that the nature of the river has completely changed. Revd Ormerod, author of *Calderdale*, refers to the fact that it has become not the delightful river of Cliviger and Towneley Park, but a 'paved channel'. He does not add that this channel was a rubbish-filled danger not only to the fish and insect life that lived in it but to the health of the many people who lived and worked nearby.

This stone channel, encased in high stone walls, determines the route that the modern Calder takes through Burnley. Whereas other towns have made something of their rivers, Burnley has turned its back on the Calder, and also the Brun, which is perhaps even more affected than the stream into which it disgorges. The work of the Ribble Rivers Trust will go some way to change the perception of the people of Burnley to their rivers.

It is supposed that the channels were constructed because of concerns relating to public health and in an attempt to control flooding, but they have also had an affect on the wildlife of Burnley's rivers. An inspection of both the Calder and the Brun will reveal that there have been obstacles to wildlife, including fish, at the confluence of the rivers. This site can be viewed from Active Way. In the past, the Royle Road foundry and Cherry's dye works were located here, as were several small cotton mills, one of which, Cuckoo Mill, is still standing.

Fish passes have already been installed by the Ribble Rivers Trust and in 2013, with support of the Heritage Lottery Fund, the trust has begun to alter the paved channels by the construction of pools that will allow fish to swim up river in both of the steams. In the past, the upper waters of the rivers abounded in trout, but the speed of the water, confined as it has been since the construction of the stone channels, has limited the number of fish that have been able to get through. The Brun is, perhaps, worse off than the Calder because a considerable length of it

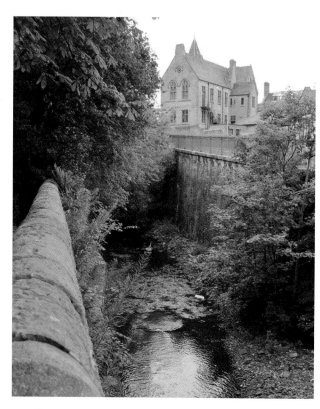

The incised meander of the Brun separates the parish church from the old grammar school.

Burnley's shopping centre is built over much of the Brun.

was built over during Burnley's 1960s/70s market and central shopping development. The dark tunnels, each over 150m in length, are another barrier to life.

Another aspect of the Ribble Rivers Trust's work is to encourage the growth of vegetation near the newly created pools and on the riverbanks. This will not only help to stabilise the ponds that will slow the flow of the rivers, but will provide habitat for a number of birds, fish, animals and insects.

It is not generally realised that there was once a thriving willow growing industry in the area of the Burnley Water Meetings, as they were called. In fact, the old name for the area is Salford – 'the ford where the willows grow' – from the Latin term for willow, *salix*. The white willow, for instance, is *salix alba*, though I suspect that the most common of the willows grown here was *salix viminalis*, better known as the osier, which has pliable twigs used in basketry. The making of baskets was a significant industry in Burnley in the late eighteenth and early nineteenth centuries, and there were, at this time and for some years after, street names associated with the trade. Basket Street, near the Culvert, was one while Poke Street stood on the site of the present market hall. A 'poke' was a bag or a pouch and the word is best known in the phrase 'a pig in a poke', a blind bargain.

The osier beds of the past stretched from the banks of the Brun, beyond the railway viaduct towards the Royle Estate, which we will visit soon. Before we do so, we should mention the route of the Calder from Handbridge to the Water Meetings, as it passes some significant buildings.

At Handbridge, the river is soon confined by former cotton mills. These are a shadow of their former glory, if that word can be applied to buildings like these, but they include Spa Mill, the mill at the centre of the 1878 riot, which took its name from the open-air pool mentioned above. Fulledge and Pentridge Mills were built in 1854 and around 1860 respectively, and were occupied by Lomas & Tunstill, cotton spinners and manufacturers, in the 1870s. The two families, especially the latter, were amongst Burnley's leading industrialists, but the mills themselves have a chequered history. At a later date, Fulledge Mill was divided into smaller units and then later occupied by the Universal Boiler Co. Ltd, the makers of tankers, and then the Economic Gas Co. Ltd, which made domestic gas fires. Pentridge Mill, which is still standing, was made into a dye works and, in 1910, part of the building became one Burnley's first cinemas, the Pentridge. Afterwards the same premises served as the Circulation Club and, most recently, as a boxing club.

There were a whole host of mills on the route of the Calder, but the Oxford Road Bridge is the site of a murder – thankfully not an actual murder, but one that is central to the plot of John W. Kneeshaw's novel, *The Calder's Secret*. I won't spoil the story, but it takes place during the Cotton Famine (1861–65) when there was much mistrust between masters and their men. An unpopular master is murdered and found in the river and, of course, the wrong man, the hero of the story, is accused. I can't pass the Oxford Road Bridge without thinking about the murder that never was.

From Oxford Road, the river passes under the Calder Aqueduct of the Leeds & Liverpool Canal. This part of the canal is the famous Straight Mile, otherwise known as the Burnley Embankment, one of the seven wonders of the British waterways. The embankment is the largest of its kind in the country and the Transport Trust, with the help of Burnley Civic Trust, recently acknowledged its importance with one of their large red plaques. This can be found under the culvert, erroneously so-called as the culvert is actually an aqueduct.

On the other side of the canal, the Calder meanders by Burnley's new Tesco store and enters an area formerly dominated by Burnley's Gasworks of 1823, the old electricity generating station of 1893, and the former council's destructor works. Unromantic you might think, but these three facilities worked together and, because of it, the town's recycling rate was usually over 90 per cent in the 1920s! All of this was destroyed by the post-war Labour Government's nationalisation policies. On the right bank of the river was Burnley's former cattle market, which was used for years as the site of the town's annual fair. Now this land is the site of Burnley's police headquarters

(buildings such as this can't be called stations any more) and the town's magistrates' court. If you visit, cast your eyes over the Burnley Library building. Remind you of anything? It should. The building was designed only a few years after Howard Carter's discovery of Tutankhamen's tomb and there are a number of references to Ancient Egyptian art and architecture on the structure.

The river progresses through another old industrial site before it reaches Burnley's town hall. This impressive building was opened in 1888, and it is well worth a visit. When the town hall was built, it was designed not merely to be a town hall. It was to be a police station with prison cells, a magistrates' court and it was to have a swimming pool as well! One of the cells (there are thirty in all) is left just as it was in 1955, when the police headquarters on Parker Lane became the new home for Burnley's police. I can honestly claim that I have been locked up in it! I was about nine at the time and my younger brother and I were willing participants in a game devised, at our request, by my father, who worked in the town hall. Eventually, he let us out, something he said he regretted thereafter. I think (I hope!) that he was joking.

Burnley Town Hall has some splendid Roman-style mosaics, a magnificent painted ceiling in the council chamber and some interesting stained glass, but its exterior has been criticised, unjustifiably in my opinion, by a number of so-called experts. I like the building and, to me, it is one of those structures that the more you look at it, the more there is to discover. I am often asked why there are so many unfilled niches (where there might otherwise have been statues) on the Manchester Road elevation. I reply that they were designed to be filled by images of Burnley's twelve famous men, but that none have yet emerged! It gets a laugh from locals and visitors alike.

People in Burnley do not realise that the town hall is either the first building in town or the last, depending on one's point of view! Until Victorian times, the Calder formed the boundary between Burnley and Habergham Eaves – incidentally, most of Towneley was in the latter. In fact, when the two townships merged in 1861, there were more people living Habergham than there were in Burnley!

We could follow the river and describe the town it passes, but there is not the space to go into such detail. There are important buildings, like the new £80 million Burnley College and University of Central Lancashire complex, Stoneyholme Recreation Ground, where Burnley FC played their first matches, and the Royle Estate, but I propose to deal with these, and other important sites, elsewhere. Suffice it to say, in this part of the town, the Calder is first joined by the Brun and then, on the other side of the Royle Estate, by the Pendle Water, the two river systems that are the subjects of the next two chapters.

Urban River Enhancement Scheme

The Ribble Rivers Trust has been carrying out in channel works as part of the Urban River Enhancement Scheme, a project designed to naturalise the River Calder as it flows through Burnley Town Centre. This has been supported by The Heritage Lottery Fund and The Environment Agency, and carried out by William Pye Ltd.

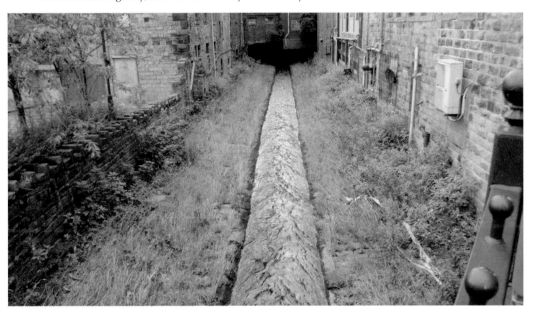

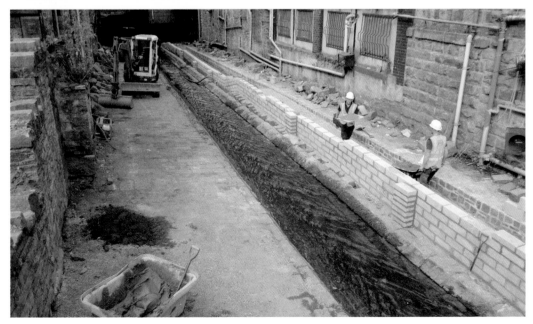

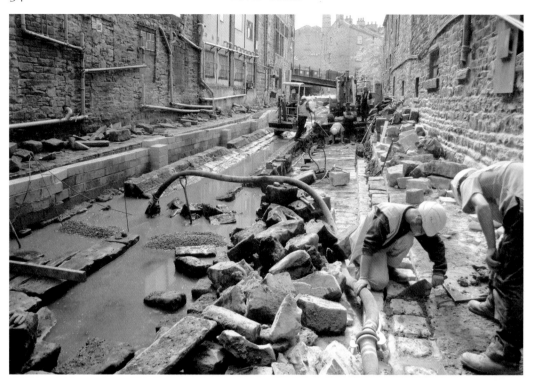

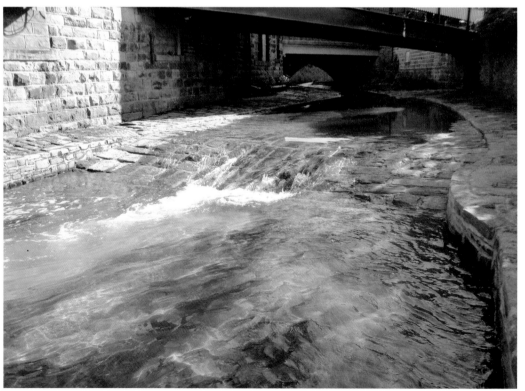

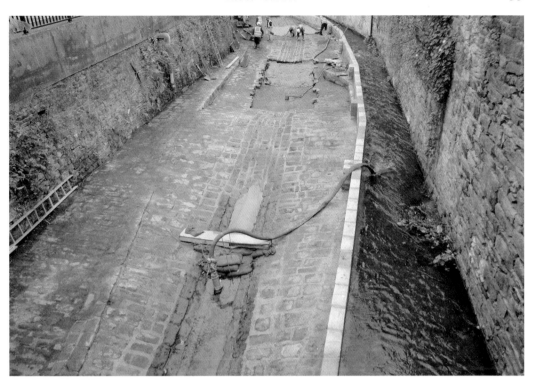

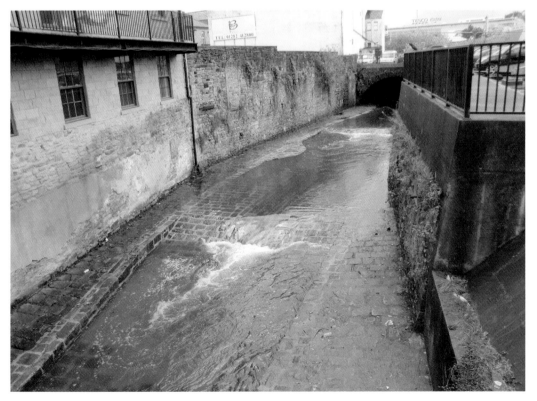

3

The Brun Catchment Area

> Eastwards is a vast upland with rarely a house or barn and with no roads except the lost tracks of ancient races; Worsthorne Moor, Black Hameldon, Stiperden Moor and thence over the Yorkshire boundary to the moors of Widdop, Gorple and Heptonstall. That is a wild region indeed, uninhabited. Yet a glance at the map and you see that the whole area is scattered with the camps, defences, mounds and burial-places of early times.

This is Jessica Lofthouse's introduction in her book *The Three Rivers* to one of the two most important of the Calder's catchment areas. Her description, which is confined to the nether parts of the book, refers to the remote lands where the infant Brun can be found. Her views are shared by the earlier observer of this vastness, the Revd Mr Ormerod writes in *Calderdale*,

> The Brun takes is source in the wild, pathless moorlands which lie in the highlands between Lancashire and Yorkshire. Bleak, treeless and almost uninhabited, they retain to this day those features, which made them the fitting home of superstition and romance, and it is impossible to wander over their trackless wastes without an "eerie" feeling akin to that which made our grandfathers unwilling to cross them after nightfall.

Mr Ormerod's observations refer to the area that is perhaps the most haunted in England. We have already been introduced to the Valley of the Goblins, which is situated here, and Waugh, writing of the Cliviger in his *Pictorial History of Lancashire* (1844), tells the frightening story of Loynd, the witch who, according to him, was the terror of all Blackburnshire.

The incident (which involved a traveller, Miles Greenwood; a talking black cat; a flash of light and a witch, possibly Loynd's wife, sitting aside Eagles Crag) refers to the home of the Lancashire Witches, Malkin Tower, situated in the valley of Pendle Water, just to the north of that of the Calder and that of the Brun. 'Loynd' was either John of that name or Jennet, his wife, but they are associated not with the famous Lancashire Witch Trial of 1612, but a later witch incident in 1633/34. Superstition, important as it is in the story of the valleys of the Brun and of Pendle Water, is not the only topic of interest, but we find ourselves on the moors above Hurstwood, as was the case with Jessica, on a foggy day in November. 'Surely, you won't go in this. Burnley is no beauty spot at the best of times – but in a fog!' Jessica was, of course, made of sterner stuff and she caught the bus to Padiham and then another to Burnley, where she found that the fog had not lifted. Thinking of making her way home, the bus for Towneley came in and she found herself getting on and visiting the park.

Her description of it does not accord with what we have already read about Towneley. 'A deer park?' she asks. 'A dismal mile of hen-pens, empty cabins and grey box houses. It was a grey morning, and no hen-runs look cheerful without hens – but I doubt even if summer and buckets full of eggs could make the deer park an asset to the Towneley Pleasure Grounds. I was glad to get into Red Lees Road, and by a group of fine old houses to find the field-path way.'

Jessica does not describe the origins of the Brun, though she revels in nearby Hurstwood. 'Authentic Tudor England, a large unspoiled slice of it,' she observes, and by Foxstones Bridge on the old packhorse route into the village, the Brun is created from the confluence of two delightful streams, Hurstwood Brook and Cant Clough Beck.

Hurstwood Brook rises at Wether Edge on Hameldon, just north of the old Gorple Road and Cant Clough Beck, as Black Clough on Worsthorne Moor, just west of Black Hameldon, on the county boundary. Both Hurstwood Brook and Cant Clough Beck are now captured by reservoirs built by Burnley Corporation in 1925 and 1892 respectively. However, the former provides walks with splendid views and cycle tracks much appreciated by young sportsmen and women.

The village of Hurstwood is a delight, something that might not be suspected to exist so close to industrial Burnley, but Jessica's description of it is just about right. The name means 'wood wood' in two different languages, and is first mentioned in 1285. In truth, however, the Tudor core of the village is joined by handloom weavers' cottages from the late eighteenth and early nineteenth centuries, some buildings from the later nineteenth century and a modern development, just off the road to Worsthorne. These additions have not prevented several filmmakers from using Hurstwood as a location for their dramas.

The principle building is the splendid Hurstwood Hall, and over its Tudor-arched doorway is an inscription naming Barnardus Townley and Agnes Townley as its builders, giving the date 1579. It is speculated that this might be the master mason Barnard Townley who started the building Hoghton Tower in the 1560s for Sir Thomas de Hoghton. Opposite the hall is a large aisled barn, the Great Barn, which is also likely to be sixteenth century in origin. It has been beautifully restored in recent years and is now an attractive house.

Another sixteenth-century building in the village, Spenser's House, claims an association with Edmund Spenser (*c.* 1553–99), the great Elizabethan poet. It is an H-shaped building with a porch, which is probably from the seventeenth century when the formerly open hall was ceiled over and the cross-passage walled off.

Edmund Spenser, the author of 'The Shepheardes Calendar' (1579) and the 'Faerie Queene' (1590), is believed to have spent some time in Hurstwood when he came down from Cambridge

Left: Peat exposed on the moor about Hurstwood Reservoir is vulnerable to further erosion. Cotton grass is the pioneering plant attempting to secure it. *Right:* Berms made of coconut fibre are secured in place to help 'dam' the eroding peat.

in 1576. If so, it may be that his visit inspired him to include verses in the 'The Shepheardes Calendar', and it has been speculated that the Rosalind who appears in the poem, and several other of his works, was a girl from the village. Recently, however, it has been suggested that Rosalind was Spenser's wife and if he came to Hurstwood at all he was not alone.

Spencer is a local surname, and there were Spencers living in Hurstwood and in the surrounding area, but it cannot be proved that the poet Spenser spent any time in the village. The best that can be said is that lines in 'The Shepheardes Calendar' appear to have an affinity with the area, but that is all. Similarly, it has been suggested, from the study of heraldry, that the Spencers of Hurstwood may have had some connection with the Spencers of Althorp, the family of the late Princess Diana, who was a distant relation of Sir Winston Spencer Churchill, the British wartime Prime Minister.

The next building of interest is Tattersalls House and, in this instance, it is not difficult to authenticate an association with a famous man. The building, a farmhouse, is probably of the seventeenth century, though it may be that there are the remains of an earlier structure on the site. Richard Tattersall, the founder of Tattersalls, the world famous bloodstock dealers (though now of Newmarket) that bears his name, was born here.

Setting out in 1746 to seek his fortune in London, after apparently being involved on the losing side in the Jacobite Rebellion of 1745 and being something of a 'marked man' because of it, Richard found success. Not only was the Tattersalls auction house a direct consequence of his move, but so was Tattersalls Ring, which you will find on most racecourses. A third achievement was creation of the Tattersall check, a design particularly popular in shirting material. It is supposed that Richard covered his horses in cloth of this design when they were being taken to the sales. The cloth attracted the notice of the aristocracy who began to wear clothes of the Tattersall design and it is still popular today.

Quite a lot for such a small village to achieve, and we have not mentioned everything. It is best, however, to visit the place, have a good look around and go for a walk through the heavily wooded property owned by United Utilities, the suppliers of water to the whole area. There is a car park, owned, I think, by Worsthorne Parish Council, so don't park in the centre of the village. There is even a small tea room in the former General Baptist church open most weekends and run by very friendly volunteers.

A beautiful day looking out across Hurstwood Reservoir.

Not only was the reservoir built well, it was built with style!

Now undergoing renovation, this is Hurstwood Gauge House.

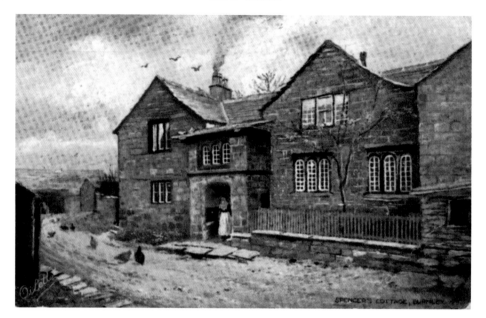

Spenser's House in years gone by.

The aisled barn, Hurstwood.

In the centre of the hamlet is Hurstwood Hall.

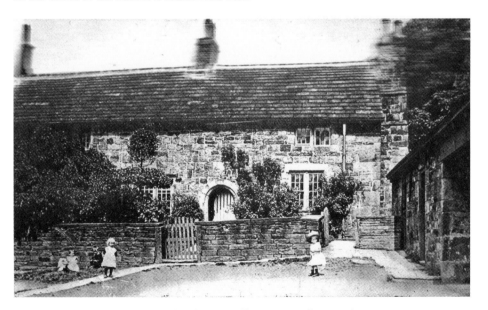

Tattersalls, the birthplace of Richard Tattersall, Hurstwood's most famous son.

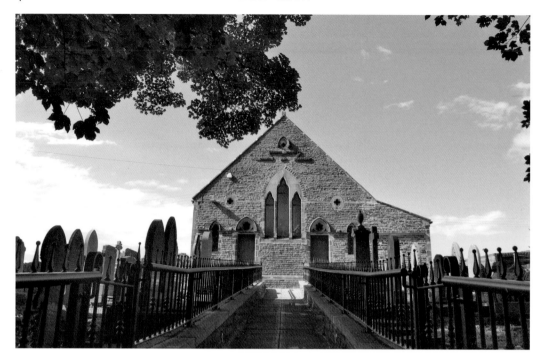

The former General Baptist church, Hurstwood.

Within the wooded area below Hurstwood Reservoir, this lake is a treasure waiting to be discovered.

The village square, Worsthorne.

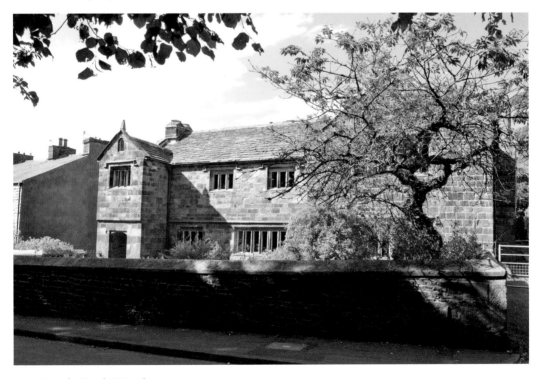

Gorple Road, Worsthorne.

The next place of interest is Ormerod House, which is on the banks of the Brun, west of Hurstwood. The house was built by George Webster of Kendal, but today only a gateway survives, dated 1834. It is copied from the seventeenth-century gateway at Barcroft Hall, only a short distance away. The gateway is stepped and crenellated over an arch with zigzag.

The house, which was in Cliviger, was the home of the Ormerods of Ormerod for several centuries. It was acquired by the Hargreaves family, who owned many of Burnley coal mines, when Colonel John Hargreaves succeeded to the estate through the rights of his wife, Charlotte Anne Ormerod. Charlotte was the sole heiress of the last male of the family, her father Lawrence, who died in 1793. When the Hargreaves family died out in the male line, they were succeeded by the Thursby family, who took over the running of the collieries. Ormerod House saw a visit from royalty in 1886 when Prince Albert Victor, the elder son of Edward VII, came to Burnley to open the town's Victoria Hospital. The building was demolished just after the last war, though several properties in the park, including the former servants' quarters and the stables, have been converted for living purposes.

Parts of the tall estate wall of Ormerod can still be seen on Salterford Lane, where there was once a coal mine. It was opened in 1948 because the reserves of coal at Salterford were out of the reach of Towneley Colliery, the underground workings of which extended in this direction. The mine was only open for eight years but there was a theory prevalent at the time that the house was pulled down because it had been undermined. In recent years, this has proved not to be the case and that the reason for the demolition was that its twin towers were not built on firm foundations. The stress they caused to the building resulted in its instability. A fish farm was established on part of the mine site some years ago, but this too has closed.

The village of Worsthorne, a short walk up the lane, which here becomes Ormerod Street, is also worth a visit. Unlike many local villages, Worsthorne sports a square on or close to which are most of the main buildings. Jackson's Farm and Wallstreams were both built in the seventeenth century.

The parish church, designed by Lewis Vulliamy, was built in 1834/35, at the same time as Ormerod House. It was commissioned by the Revd William Thursby, the first of the Thursbys, who had succeeded to part of the Hargreaves' estate in the right of his wife. Initially, the church did not have its impressive west tower, but this was added in 1903. However, the interest to me in Worsthorne is the handloom weavers' cottages of the early nineteenth century and the mysterious Red Man who presides over Ormerod Street.

The village has two excellent pubs, the oddly named Crooked Billet and the Bay Horse. There is even a microbrewery producing Worsthorne Ales, but this is in neighbouring Harle Syke, which is in Briercliffe. Incidentally, a crooked billet is literally a bent or crooked stick or other piece of wood shaped like a shepherd's crook and, given the pastoral nature of farming in these parts, it appears to be a suitable name for the pub.

Back at Salterforth Bridge, the Brun makes its way to Burnley passing the Hollins, the last home of the Baroness O'Hagan, one of the Towneley heiresses. The Hollins was also the childhood home of Philip Gilbert Hamerton (1834–94), the artist, art critic, writer and novelist. He had been born near Crompton in Lancashire but, as his mother died when he was only two weeks old and his father showed little interest in him, the boy was sent to live with his father's two unmarried aunts and their mother at the Hollins. From here he attended Burnley Grammar School and, when still young, made his first literary attempt, a book of poems that failed. He then took up landscape art, in which he made a name for himself.

His first real success was a book called *A Painter's Camp in the Highlands, and Thoughts About Art*, which was published in 1862 and was an account of a prolonged stay on an island in Loch Awe. In 1866, he wrote *Etching & Etchers*, which became the standard work on the subject. He became the art critic of the *Saturday Review*, a leading periodical of the day, but he left to set up his own journal, *The Portfolio*, which he edited for many years. As an art critic, Mr Hamerton has been compared to John Ruskin, but the latter was a great polymath, which the former did not

The lake at Rowley.

pretend to be. That said, PGH, as he was often known, still deserves to be read and there are a number of his paintings in the collection at Towneley.

In his autobiography, Hamerton remembered life at the Hollins most affectionately, and he never lost a love of the place.

> Hollins is situated in the middle of a small but very pretty estate, almost entirely surrounded by a rocky and picturesque trout stream, and so pleasantly carried by hill and dale, wood, meadow and pasture that it appears much larger than it really is. In my boyhood it seemed an immensity, these boyhood recollections, and an early passion for landscape beauty, made Hollins a kind of earthy paradise.

Hamerton became very well known is his lifetime, though he married a French lady and lived in France. In 1882, he returned to Burnley with his wife and family, where he was given a civic reception at which he received many flattering speeches.

After Hollins, the Brun makes its way to the Brun Valley Forest Park, which is being developed jointly by Burnley Borough Council and the Lancashire County Council. The vision for the park came from Burnley's Green Spaces & Amenities manager, Mr Simon Goff, who was instrumental in getting the funding for the Millennium Forest of Burnley Project in which 1.2 million trees were planted, the most successful project of its kind in the country. The work at the forest park will take longer to achieve but it covers a wide area of the eastern part of Burnley and is centred on the restored site of the Rowley Colliery in Worsthorne. The facilities in the park, which is not yet complete, will include the Brun Valley Greenway, with links to the Burnley Way and the Towneley Way. There are facilities for walking, horse riding and for bike riders, and the beautiful, quiet Rowley Lake attracts many birds and is used for fishing and picnics. Angling is gradually being improved by the work of the Ribble Rivers Trust, which has designed and installed easements and fish passes along the rivers Calder and Brun.

The plan for the forest park is to provide a huge green lung that will not only serve the communities of eastern Burnley, some of which are counted amongst the most disadvantaged in the country, but it is hoped that the park will have a regional impact. It includes the existing Thompson, Queens and Bank Hall Parks, bringing into the equation all that they offer together with the developing facilities in Heasandford. There you will find, for example, the Burnley Youth Theatre, one of the great forces for good in Burnley and one of the town's most prized possessions. It sits in an interesting position on the site of the Heasandford Quarry, which supplied material for the old Heasandford Brick & Lime Co. that had brick kilns by the canal, suitably close to the Bank Hall Colliery, Burnley's biggest coal mine.

What is not generally realised is that the quarry was once the haunt of numerous amateur geologists because of the variety fossils found there. At one time, the quarry was known to professional geologists too, and there are still a number of households in Burnley that have specimens from Heasandford, though I suspect that many of their residents will have forgotten where they came from.

Below the site of Rowley Colliery (incidentally, it is pronounced 'rhulie', from the medieval spelling) the Brun cascades noisily on a new route towards Swinden Water, which joins the Brun halfway between the colliery site and Netherwood Farm. In the past, the Brun joined the River Don a little to the west of the present confluence, while Swinden Water had already joined the Don. The change was a necessary part of the 1970s River Brun Diversion Scheme and produced a cascade, which is both one of the features of the Brun Valley Forest Park but also a barrier in the environmental sense. The scheme's intention was twofold: to make way for a landfill site at Rowley and to rid the river of pollution. The pollution took the form of bright orange water, which came from the flooded workings of the old Rowley Colliery. It was not only ugly to look at, leaving an unpleasant deposit on water courses for some distance down river, but it had an adverse effect on water quality and the aquatic life of the river.

The scheme has been tremendously successful and the waters of the Brun are much improved. Its two feeder streams have not had the pollution problems of the Brun, largely because they have not been subject to mining on the same scale. However, higher up stream, on Swinden Water, there were mines in the past. They were small-scale, surface bell pits rather than shaft mines and sufficiently far away from the stream not to cause major problems.

The valleys of the Don and Swinden Water are now our subjects. The River Don, the shortest river in England, has one of the oldest names for a river. The word 'don' comes from the British (i.e. pre-Roman) word 'dana', which simply means 'water' and, in the case of the local Don, the age of the name is particularly appropriate because of the prehistoric burial mounds that can be found in the upper part, not only of its valley, but also the valleys of Swinden Water and Hurstwood Brook. Of these steams, the Don has the largest number of prehistoric sites.

There are two possibilities for the source of the Don: Hay Slacks Clough, which begins on the other site of the Yorkshire border, and Rapes Clough, which is high above the Valley of the Goblins at Thursden in Briercliffe. Rivers are rarely as simple as this. Hay Slacks Clough becomes Black Clough on the Lancashire side of the border, which in turn becomes Thursden Water when the stream enters the valley of that name. Then, near Cockden Bridge, it becomes Cockden Water, ending up as the Don less than three-quarters of a mile from the confluence with the Brun.

The Swinden Water is a different matter. Though it is joined by several very small streams, it is not subjected to a change in nomenclature, being known as Swinden Water for the whole of its length. The name simply means 'the valley of the pigs', which may or may not have been the wild boar of olden days.

In the Middle Ages, the township of Extwistle, which lies between the Don and Swinden Water, was mostly in the ownership of two religious houses. The Extwistle Hill, or western part of the township, was in the hands of the Premonstratensian Abbey of Newbo, near Grantham in Lincolnshire. Granted to the abbey at the end of the twelfth century, it remained in its hands until the Dissolution of the Monasteries by Henry VIII in the mid-1530s. We know little about

how the monks managed their Extwistle lands, but it is supposed that they had a small grange for sheep. It is known that there was a corn mill on their lands and its remains and watercourses can still be seen to this day.

I suspect that Newbo's property in Extwistle was leased to a third party, and this is supported by the Valor Ecclesiasticus, an assessment of monastic wealth compiled in the reign of Henry VIII. The abbey had properties in Lincolnshire, Nottinghamshire and Lancashire. For the latter there is one entry but it refers to two places, Extwyssell and Brokilhurste. The property is described as a 'firm' (farm – in the sense of a property that is let and produces an annual income) with an income that is stated as being £4 and 12 pence. We might think that this is an odd way to record an income, as there were 12 pence to a shilling, but it was a quite common way of recording financial matters, often representing the actual coinage transacted.

There is another reference in the Valor that might be of interest. This is the name of a rectory in Yorkshire (*Co Ebor*). The name is given as Akaster, now known as Acaster Malbis, a small village south of York. The site of a Roman fort, Acaster was the home of the knightly Norman Malbysse family, and one of them, a particularly disreputable individual, enters our story.

This was Richard Malbysse, probably the Lord of the Manor of Acaster. It was this Richard who granted part of Extwistle to Newbo in around 1190. It was a seemingly innocent gift, probably made, it might be thought in these religious days, for the benefit of his soul. But if you ask about Richard in York, you will hear a very different story. In 1190, Richard Malbysse was preparing to join his King, Richard the Lionheart, on the Third Crusade and, taking advantage of the anti-Semitic sentiment of the time (there had been anti-Jewish riots even at Richard I's Coronation), he instigated what we would now call a pogrom in York.

Malbysse – his name means 'evil beast' in Norman French – was in debt to a Jewish banker in York and he, together with a number of other indebted landowners, demanded back the records of their debts. As these were not forthcoming, riots lasting three days broke out in the city on 15 March 1190. The houses of the leading Jewish residents were sacked and the widow of Benedict, a leading banker in York, was murdered. The others, with the help of the constable, took refuge in the castle, but some who failed to get there were either forcibly baptised or massacred.

Things went from bad to worse as the sheriff ordered that the castle be attacked. What happened next is not entirely clear. Writers have claimed that some of the Jewish residents committed suicide in the castle, but this has been dismissed by others who argue that what happened in York has been confused with the Masada incident of AD 73/74 when perhaps over 900 Jewish people, under siege to the Romans, decided to take their own lives rather than fall into the hands of their enemy. However, what is known about that day in York is that on the promise of a free passage, the Jews decided to leave the castle but many were massacred as they left the building. It has been estimated that around 150 lost their lives in the York incident.

The financial records, the return of which had been demanded by Richard Malbysse and the other landowners, had been stored for safekeeping in York Minster. It is likely that they were in the form of tallies (pieces of wood marked to indicate the details of a financial transaction and split in two, the lender taking one half, the borrower taking the other) and it is understood that they were destroyed in a great fire there.

When the king heard of what had happened in York, he sent officials to the city who dismissed the sheriff and the constable and arrested and punished the instigators of the pogrom. Richard Malbysse lost his estates and two of his esquires were thrown into jail. However, it is thought that the king relented and that the gift of land to Newbo can been seen as one of the reparations demanded of Richard Malbysse for his involvement in the massacre of the Jews. What is clear is that Newbo held on to these lands for over 340 years. Extwistle Hall was built on this land in around 1585 and there will be more of this later.

Before we dispense with Richard Malbysse, it ought to be recorded that he was also the man who granted the larger part of Extwistle Moor to Kirkstall Abbey in Leeds. This Cistercian house had been founded in Barnoldswick in the eleventh century, but it moved to Leeds a few years

Atmospheric Extwistle Hall.

later and, in 1190, it too found itself the beneficiary of a landed gift from Richard. This time we know how it was used as the Grange at Monk Hall was at the centre of sizeable sheep farm. What is different is that Kirkstall had control over this property for only a relatively short time. When the abbey experienced difficulties in 1287, the property was disposed of to the Earl of Lincoln.

There is a building in Extwistle still known as Monk Hall, but the building is not the one owned by the monks as it dates to around 1600. However, there is a chapel dedicated to St Benedict, the founder of monasticism, attached to one of the four houses converted out of farm buildings there. It is open to the public for much of the year and is the project of Vena Eastwood, an expert on the Rule of St Benedict.

Extwistle, given its size and population, has more ghost stories than you might imagine. The story of 'Fair Alice of Extwistle' is really the title of a novel by John W. Kneeshaw, but locals often quote it as a ghost story. In the Holden Valley there is a Black Dog story, and at Lee Green, a farm in the township, there is another story that recounts how the Devil was raised and, after a fearsome fight, laid to rest by 'bell, book and candle' under the original site of the Nogworth Cross. Only the base of the cross survives to this day, but part of the story tells of the legend that if ever water ceases to flow in Holden Clough, the Devil will be released.

In addition, the now ruinous Extwistle Hall, once the manor house for Extwistle, is the site of one of the most interesting of the stories. This involves Captain Parker, the owner of the estate in the early eighteenth century. He was a great huntsman and his exploits have come down to us in the words of the 'Extwistle Hunting Song', a favourite, until about 100 years ago, of the regulars at the village pub, the Roggerham Gate.

The story tells of Captain Parker returning on a dark evening from a hunting expedition. As he felt that he was being followed, he hid himself in some bushes close to the path he was walking on. He waited, and sure enough he heard strange voices approaching him. At first he saw nothing, but, as the moon appeared from behind the clouds, a number of tiny individuals

could be seen. They were carrying something, a box the weight of which looked too much for the mischievous goblins now approaching. Captain Parker noticed that the heavy box was a coffin, larger than they would have needed had one of their brood passed over.

With a look of horror, Captain Parker noticed the name on an inscribed copper plate: it was his own! The goblins walked on without acknowledging the Captain, though he felt that they were very much aware of his hiding place. The Captain made his way home and was glad to be within the safe walls of his manor house. He took off his coat and hung it up to dry in the fireplace, forgetting that he had a horn of gunpowder on a pocket. Tired, the Captain fell asleep and the gunpowder exploded, damaging the house severely. Captain Parker was injured and was soon dead; fulfilling the warning he had been given by the noisy goblins.

This story is one of the few that can be authenticated. Captain Parker was Robert Parker (1663–1718) who, in 1710, became the second member of his family to become Sheriff of Lancashire. Dr Whitaker, the historian, notes in his *History of Whalley* that on 'Thursday, March 20th, 1717–18, Captain Robert Parker, two daughters, Mary Townley, Betty Atkinson, and a child, were much damnified by gunpowder, and two rooms much damaged. Monday, April 21st, 1718, Captain Parker died'.

It is sad to see the hall in the ruinous condition that it is in now. There have been several attempts to restore the building, one of which had it as the clubhouse of a new golf course – it was to be the Gleneagles of the north – but nothing came of it. Another used the hall as a convent for nuns and there have been a number of people who would have liked to restore the building for residential purposes. There is even a plan for the building of houses on land not too far away from the hall in exchange for the restoration of the building.

Extwistle Hall has been there for nearly 450 years, but its destiny seems to be that it will survive only as a picturesque ruin. Roggerham Mill is another ruin in the valley just below the hall. Built as a water-powered corn mill before 1610, it was also used in both the woollen and cotton industries. A steam engine was added in the nineteenth century, but this mill should not be confused with the monastic corn mill lower down the valley.

We have mentioned the stone-built village of Roggerham. The only village in Extwistle, it lies close to Swinden Water. The old village school, built in 1802/03, survives as a cottage, but it is interesting as it is one of the homes of the 'Sage of Roggerham', Tattersall Wilkinson, who contributed much to the study of the local history of Extwistle and his native Worsthorne. He was also interested in archaeology and undertook a number of digs on the moors above Roggerham, claiming a number of prehistoric and Roman finds.

Opposite, the schoolhouse is the site of the bullring, but the building that dominates the village is the Roggerham Gate Inn. The present inn dates from 1885 but the old inn is actually located next door, and many years ago, there was a sign attached to the wall of the inn. It showed a flock of sheep, Joseph Preston, one of the brothers who kept the inn, and a prominent five-barred gate. The sign also had the following short poem:

> This gate hangs free and hinders none,
> Refresh and pay and travel on.

A walk along the valley of Swinden Water is full of interest and eels ('snigs' we call them in these parts) have recently returned to the stream, as have trout and other freshwater fish. Three reservoirs are encountered on such a walk, which have been a refuge for a number of wild birds. I am particularly fond of the coot that can be found here. A survey, completed in 2003 after ten years of work, revealed that a least 114 species have visited the Lee Green site alone. These include the great crested grebe, the cormorant, the grey heron, the mute swan, the widgeon, the goldeneye, the merlin, the water rail, the oystercatcher, the redshank, the kingfisher, the skylark and the dipper. I am grateful to Mr Malcolm Higgin of Briercliffe, the well-known ornithologist, who has allowed me sight of his Lee Green records before their publication.

Extwistle Hall, a much haunted house.

We now turn to the River Don. We have already visited the Valley of the Goblins, where the stream bears the name Thursden Brook, and we have noted some of the remains of the lime hushing industry of the area. It is difficult to believe that this remote valley was as populous as it once was. Not only was there the shooting in the woods near Monk Hall, which were planted for that purpose, and the occasional employment offered by the extraction of lime, there was an amazing number of occupations for the residents of the past. There was farming, of course, mainly pastoral, the quarrying of stone, the curing of leather, handloom weaving and there was even a patch of ground (still identified today), which was used, even in the conditions that prevailed here, to grow flowers for the markets in Burnley and Colne!

Other things that make this valley remarkable must include the huge Independent Methodist chapel of 1813, which was built by the astounding Jonas Lee. He is thought to have been the model upon which George Eliot based her character Adam Bede in her novel of that name.

Although not a builder, or trained minister for that matter, Jonas converted the great part of what had been a large handloom weavers' tenement into Thursden chapel. He installed rough pews and, according to the legend, made a pulpit out of an old gig. A 'lectern' was fixed to the splash board and one of the wheels of the gig must have been in full view of the congregation, for Jonas is reputed to have preached from the text 'A cart wheel' (Isaiah 28:27) on a number of occasions. He interpreted the knave of the wheel as being Christ, the twelve spokes as the Apostles and the rim of the wheel he likened to the world. Each spoke had a name and he would firmly take hold of 'Peter' and talk of the Apostle's stalwart qualities.

Born in around 1783, Jonas Lee was a farm labourer in his younger days and is reputed to have been the best 'mower' in the district. He went from farm to farm cutting grass by contract, and his neighbours claimed that he could mow as fast an old woman could walk, or as fast as any two men. On one occasion, two men challenged him that he could not clear the same area of grass as they in a given time but, on seeing him ready for action, they gave up the challenge!

Jonas was a stout, well-built man and his feats of strength were considerable. For example, apart from his prowess at mowing, he was known to have carried sacks of coal on his back from the pit at Marsden Height (Black Hills) to Jerusalem Farm. He built Jerusalem almost single-handedly, and many of the stone walls in Thursden were erected by him, often working alone. At one time, when going to Manchester, he found that he did not have a horse and so he rode there on the back of a bullock, only to be arrested when he arrived at his destination.

For all his amazing achievements, Jonas was a Christian first and foremost. He was a good, powerful speaker and he entered into public debates, one of which was on teetotalism at Haggate. His influence on Methodism in the Briercliffe area was very considerable. It is understood that he first became involved at Southfield Methodist chapel, in what is now Nelson, and that Jonas brought his beliefs with him when he moved to Thursden. Although that remote place lasted only to the mid-nineteenth century as a place of worship, it had a successor at High Sym, which was followed by Jehovah Jirah at Haggate and the Harle Syke Wesleyan Methodist church, which closed only in recent years. It is now a nursery for preschool children, situated in the building still known as the Tin Tab (the Tin Tabernacle).

Thursden also boasts Broadbank House. Built in 1777, it presides over the most accessible of the lime hushing areas. Both Halifax Road and Ridehalgh Lane pass through these workings that have quite significantly scarred the landscape, though local people do not understand how the work was undertaken. Dr Whitaker, the historian, visited Thursden to see for himself.

> Though the Mineralogy of the Parish does not immediately fall in the plan of this Work, it may not be improper to notice, under the township of Briercliffe, a mode of obtaining limestone, peculiar, so far as I know, to that and a few surrounding districts. In the deep gullies in Cliviger, Worsthorne, Briercliffe etc ... are found, irregularly scattered, vast beds of limestone, evidently detached from their parent rocks and worn, by gradual attrition to a pebbly form. These are now deposited at random, in beds of clay, or loose matter, and the land which contains them, being of little value, they have been, from time to time, disinterred by 'hushing', or washing away the soil, from reservoirs collected above, the outlets of which are directed at pleasure, and pointed, with much dexterity, at the remaining beds.
>
> Amidst the scenes of desolation which this strange process has occasioned, the broad beds of gravelly stones tossed about as in the abandoned course of some great river (the fantastical directions which the streams have successfully taken, and sometimes insulated masses of earth and limestone, terminating in sharp ridges produced by gradual attrition of their sides), exhibit a novel and striking appearance such as is rarely produced by any artificial cause.
>
> But the streams beneath are almost perpetually discoloured and deformed by this uncleanly operation which is carried on or near their sources, and from which the connivance of centuries has left the inhabitants, upon their banks below, without any hopes of redress.

In Thursden, the area of the local 'hushings' was known as Thursden Scars. It is very extensive, as are the Coldwell Hushings, which are to the north. Much of the latter are now beneath the two reservoirs at the site, but similar sites can be seen at Shedden in Cliviger, in Hapton, and at Scar Wood near Pighole in Briercliffe. Limestone would not have been extracted in the difficult circumstances described by Dr Whitaker if it was not of commercial use and did not have a value. In fact, the material was often of considerable use to the farmers on whose land it occurred because the lime was used on the land to improve grass, to make mortar and to make lime plaster for building. Of course, the limestone had to be burnt in a kiln and the remains of many of these can be found throughout the area. At Shedden, one such kiln has been restored by Mr Eric Greenwood and can be inspected. Kilns that have not been restored are quite common but are not noticed by walkers.

Dr Whitaker's reference to the long-term effects of hushing is significant. The process, although it was irregular, dislodged vast quantities of material that continued to wash down river, even when hushing was not taking place. This is, therefore, an early example of the pollution of the Calder and its tributaries as mentioned by Jessica Lofthouse. As we make our way down Thursden Brook, there are several places where this can still be seen and one of them is at Blackhouse Lane Bridge where there are the remains of a kiln that fired dislodged limestone, which was brought down river after hushing campaigns.

Just above Blackhouse Lane there are the remains of Monk Hall Quarries, which were opened to provide stone for the railway building projects of the mid-nineteenth century. Below were the Batty Hole Gardens, an early fruit farm run by the North of England Fruit Preserve Co., which had factories in Leeds, Birmingham and Brierfield. Incidentally, the fruits grown here were gooseberries and rhubarb, the two most popular jams of mid-Victorian times in north-east Lancashire.

Blackhouse Lane was also the home of Delma Pleasure Gardens, which supplied simple entertainment (swings, etc.) for the children and teas for the adults in Victorian and Edwardian times. There were a number of these type of pleasure grounds in the valley of the Lancashire Calder, and we will be visiting one of them in the next chapter when we meet Jack Moore's Monkey.

Calf Hey Well is also close to Thursden Brook and it has an interesting history for several reasons. The first is that the well is on the site of a late medieval holy well, and it is still possible to work out the arrangements made at the time to use the site. Another is that the well provided the water for Burnley's first piped supply, which dates from 1819. The third is, perhaps, a little more interesting. Not long after the Burnley Water Co. finished work, especially the impounding of the well, there were complaints from local residents that the fairies that had made use of the old well no longer visited the site. There is no reason to suppose that the fairies that appeared regularly at Calf Hey were not the gossamer-winged creatures of popular imagination (indeed, if they appeared at all, it is more likely that they were not) but their disappearance was the cause of great consternation to Briercliffe folk in the early 1820s and they even protested to the company, but without avail.

We come now to Cockden Bridge where the stream is briefly known as Cockden Water before it becomes the River Don. At the bridge, the Ribble Rivers Trust has been at work constructing a fish easement. The footings of the bridge, possibly an old ford, until recently presented a barrier to fish. The culprit was a concrete weir that has since been replaced by a series of smaller steps that allow fish into the upper waters of the river. These waters are now of excellent quality, but they have not supported the number of fish that might have been expected.

When I was a boy there were sticklebacks, bull heads and brown trout in profusion in Thursden Brook and, though I was not very good at it myself, my brothers and I went tickling trout. On one occasion, Tony, six years younger than me, caught a few trout and we cooked them in leaves on a wood fire in the open air. I have never forgotten that meal, and I do not think it has been exceeded even by the best efforts of some of the best chefs in London!

The Don makes its way to its confluence with the Brun through a tree-lined valley famed for is blackberries. It also contains the much more famous Ogglty Cogglty, a flight of either 139 or 141 stone steps from the river at Runcklehurst to the path by Musty Haulgh. I say 'either' because, though I have counted the steps dozens of times, I have never counted 140 of them. Logically, I suppose, there are 140 steps but when you see them, you will understand my problem. The stone steps are not regular, so it is a case of when is a step a step, if you see what I mean.

There are lots of theories about the origin of the steps (that they were constructed by a lost civilisation, for instance) but the truth is that they were laid by the parish council in around 1908, and they have been a danger to walkers ever since! There is, however, one remarkable fact about the Ogglty Cogglty. Just about half the way down, there used to be a shop. Yes, a shop. Here! It

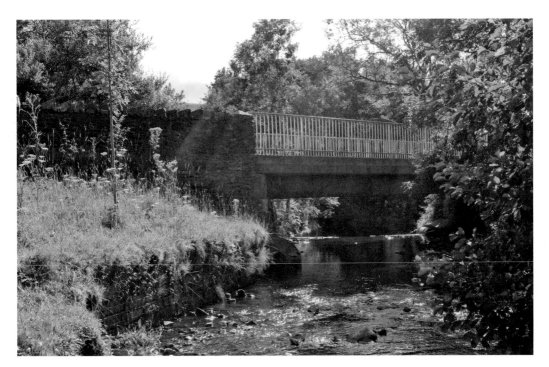

The bridge at Cockden Water.

was a toffee shop called Briary Bank where walkers could buy sweets made in the little wooden house/shop hidden amongst the trees. Treacle toffee (Plot toffee, we used to call it in these parts because of its widespread use on Bonfire Night), fudge, a brittle caramel, toffee apples and Nelson Balls (boiled mints) were all made here.

After the Runcklehurst footbridge, there is no direct access to Heasandford where the confluence can be found. I, of course, have waded through the river and scrambled along its overgrown banks to get to the next footbridge at Netherwood, but there is a better way. At the top of the Ogglty Cogglty, take the path across the fields to the bridge. It is much safer, and passing by Netherwood Farm you will soon be able to hear the Brun cascading down its new route to be joined by the Don at its ancient confluence. From here it is plain sailing towards Burnley, but a brief pause is necessary to note a fish easement and an interesting example of the national Keep Rivers Cool scheme. This work has been instigated by the Ribble Rivers Trust and the latter is an initiative to increase shade along riverbanks by planting trees. In addition to increased biodiversity and reduced erosion of riverbanks, the trees help to shade and moderate river temperatures, helping to combat climate change.

Notice the millpond on the right of Netherwood Road. Locals think this is the millpond for the present red-brick Heasandford Mill, which was opened in 1905 and was the first cotton mill in the area to be powered by electricity. I am afraid, however, that it is not. The pond was constructed for another, much earlier mill, built around 1800, which was much further downstream, close to the present Heasandford road bridge. Nothing of this mill remains as it was close to the Heasandford Quarry – now the site of the Burnley Youth Theatre – and Burnley's biggest coal mine, Bank Hall Colliery.

The colliery has gone but there are plenty of reminders of King Coal in the park that has been created on the site of the mine. You will have to look for them but they include a short branch of the canal, the route of a mineral railway, a suspended section of track from a jinny track railway and

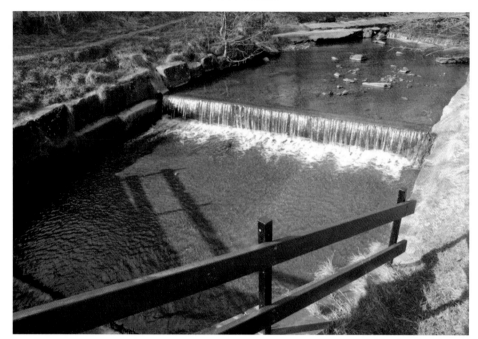

The Don fish easement before and after construction.

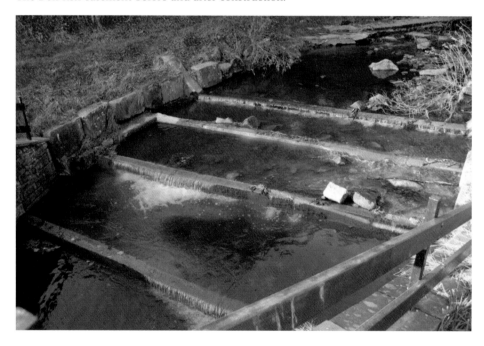

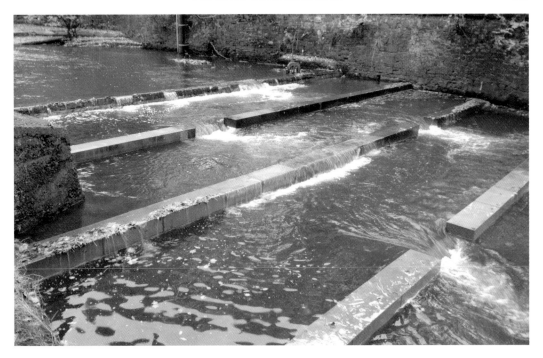

This weir was designed to feed water to the lake in Thompson Park.

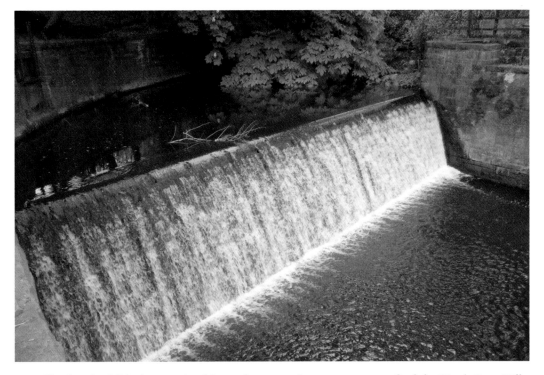

The Burnley Weir dates to the thirteenth century. Its purpose was to feed the King's Corn Mill.

the remains of coal staithes. One thing that is not easy to miss is Heasandford House. Now divided into several dwellings, it was the manor house of Worsthorne from the early fourteenth century. It was awarded to Oliver de Stansfield for his services, particularly as Constable of Pontefract, to the great de Lacy earl. There is one thing that has long since puzzled me – the house has never been in Worsthorne. It was in Briercliffe until the late nineteenth century when, in a phase of uncalled for expansionism, it was included in Burnley.

From the site of the mine, the Brun passes under the Sandholme Aqueduct to the first of two weirs. The first was constructed to provide water for a paddling pool and boating lake in the award-winning Thompson Park, which we pass on the left. The park dates from 1930 and was gifted to the town by the Thompson family, who were cotton manufacturers in Burnley, but the weir itself was another barrier to fish and has now been modified by the Ribble Rivers Trust.

The next feature is the much larger and older Burnley Weir, which was originally constructed to provide water for Burnley's thirteenth-century corn mill. The mill, known for much of its existence as the King's Corn Mill (because it became the property of the Crown in 1399), is some distance away. The weir created a depth of water in the Brun which could be drained off to power the grinding machinery in the mill. Traces of the mill race can still be seen on its route to the site of the mill. However, both the mill (now under Burnley's 1960s shopping centre) and the race have been largely confined to history and I am afraid that I had something to do with it. As mayor of Burnley in 2006, it fell to me to open the town's St Peter's Leisure Centre, and traces of the mill race were lost in its construction.

Local people are proud to call Towneley 'the jewel in Burnley's crown' and, once visited, that is fully understandable. But we have a second, and just as significant, jewel in St Peter's church, which is on the banks of the Brun. St Peter's is one of the most outstanding churches in Lancashire. The building dates to 1120 and it is likely that its foundation is much earlier. The oldest part of the building is the tower, which is 600 years old, but part of the roof of the nave is sixteenth century, and the pillars are believed to be Norman, dating to the twelfth century.

What is wonderful about St Peter's is its interior, because if ever a church told the story of the town of which it is a part, this is it. It has a magnificent master window; the Towneley chapel, which contains the remains of the Richard and Francis Towneley, who we have met in this book; the Stanfield, or Scarlett, chapel; numerous informative memorials in the nave; and the Visitor Centre at the base of the tower, designed by Brian Hall and Ken Spencer. To cap it all, the bells are some of the finest in the north of England, and it is a pleasure to hear them played so regularly by campanologists from all over the country.

The bells of St Peter's will have to play us out of the valley of the Brun. Such a story the river has told, we have not been able to discover much of Burnley Centre but that is best left to another time.

St Peter's Leisure Centre stands on the site of Burnley's medieval archery butts.

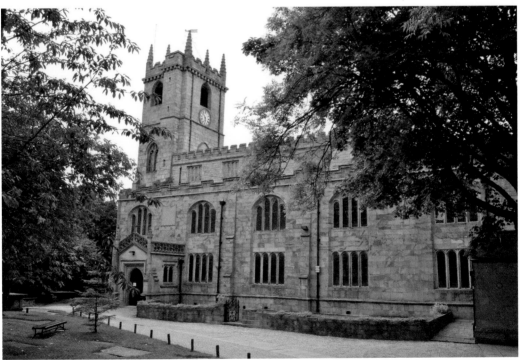

Burnley's second but no less significant jewel in the crown is St Peter's church.

4

Pendle Water & Colne Water

As we travelled we came near to a very great high hill, called Pendle Hill, and I was moved of the Lord to go to the top of it, which I did with much ado, it was so very steep and high. When I came to the top, I saw the sea bordering upon Lancashire. From the top of this hill the Lord let me see in what places He had a great people to be gathered.

These words, which were written in 1652, are from the journal of George Fox, the founder of the Religious Society of Friends, better known as the Quakers or simply the Friends. Fox was an English Dissenter born in Leicestershire in 1624, so he was only a relatively young man when he put pen to paper. The words came to him at an early stage in his public ministry, which had commenced in 1648, and Fox believed that his vision from Pendle encouraged him in his work.

People still climb Pendle Hill, not generally to share the vision of George Fox, but in an attempt the get close to one of the most enduring stories of English history, the tale of the Lancashire or Pendle Witches, who came to a grisly end on a scaffold in Lancaster, forty years before Fox arrived.

Pendle Hill is the dominant landscape feature of the district, rising to 557 metres, or 1,831 feet, at the Beacon, or what we locals call the 'Big End'. The hill can be seen from all the towns and most of the villages of Lancashire's Calderdale, and it is beyond question that most of their residents have much better views of the hill than their neighbours who live in, what some might argue, the more favoured valley of the Ribble.

The name Pendle Hill dates back to 1258 when it was known as Pennul, later Penhul, though the name is much older than that. The nearby village of Pendleton is one of the few places in the district mentioned in the Domesday Book, but the best way to understand the place name is to divide it up into its three syllables. The first, 'pen', is the pre-Roman word for 'hill' and the second, in its early or Old English spelling, 'nul', also means 'hill'. In more recent times, we have added our own word for the same feature, so the name means 'hill, hill, hill', in three different languages.

It is not only in the landscape sense that Pendle dominates the area. To a very large extent, it determines the microclimate of the whole district. Living on the Ribble Valley side of the hill means that it is likely to be a few degrees warmer and considerably drier. In the past, this had an effect on the agriculture of the area where orchards for both apples and plums were more common and far more productive in the valley of the Ribble than they were in the Calder.

On the Calder side of the hill there is a saying: 'If you can't see Pendle Hill it's raining and, if you can see the hill, it is about to rain.' When the clouds are gathering over Pendle another

The village of Barley with Pendle Hill in the background.

Pendle Inn.

saying in the Calder valley is that 'Pendle has got its cap on', meaning, similarly, that it is going to rain. Unfortunately, there is another, better known rhyme that, in part, undermines the common wisdom.

> Hodder, Calder and Ribble and rain
> They all meet together in Mitton demesne.

Local references to the weather do not end there because when the winter easterlies blow, Pendle prevents the worst of the weather getting into the valley of the Ribble. The valley of the Calder, separated by only a few miles from its neighbour, can be much colder and often has to endure much heavier falls of snow.

A feature of Pendle is the occasional but massive discharges of water that, in the past, have caused considerable flooding in the valley of the Calder. Camden mentions a notable example that took place in 1580, making a clough in the side of the hill, which is known as Brast (or bust) Clough. In a letter penned in 1699, Charles Towneley described a mighty torrent that issued from the north-west end of the hill. He added,

> The water gushed out of the top of the hill in such quantities and so suddenly that it made
> a breast a yard high and continued running for about two hours. The houses of Worston,
> a distance of two miles from the point of irruption, were so completely inundated that the
> furniture in the lower rooms was set afloat by the turbid stream.

There was another great cloudburst, as they are called around here, in Ogden Clough in 1881, which resulted in the closure of the Barley Green Mill.

The river system of Pendle Water is quite complex, and not only as a consequence of the fact that this river is still referred to as the Calder. In Barrowford, for example, there is property still known as Calder View and there is a Calder Vale Street. As might be expected, Pendle Water finds its source on Pendle Hill but, confusingly, it is not known by that name for some distance. The Ogden Clough meets Barley Water at the hidden Water Meetings in Barley village, and the newly fortified stream passes Narrow Gates as White Hough Water, becoming Pendle Water on the other side of Roughlee. The river is joined by Blacko Water – Admergill Water in its early stages – at another Water Meetings above Higherford, after which the river flows through Barrowford and Nelson on its way to Brierfield and Reedley to its confluence with the Calder near Royle Hall.

However, Pendle Water becomes a considerable stream because it is joined by another stream, Colne Water, at Lowerford near Barrowford. This stream is formed at Corey Bridge, near Laneshaw Bridge, by the confluence of the River Laneshaw and Wycollar Beck. The new stream collects Trawden Brook at Cotton Tree, to the north of Colne, and continues on to Colne itself, where it passes through the appropriately named Waterside before its confluence with Pendle Water on other side of Barrowford.

The places associated with the Pendle Water catchment area are full of history and tradition. These include much of the Lancashire Witch Country, the once abandoned village of Wycollar, now a most attractive country park, and the equally revealing town of Colne, famed for its associations with the *Titanic*, and the villages of Trawden and Barrowford. We will be visiting them all, but we should now reconvene in the delightful village of Barley. However, be warned, you will need a good map with you!

The valley of the Ogden Clough has been described by Jessica Lofthouse as

> a sombre, gloomy hollow – it is dark on a cloudy day, but very beautiful in autumn when
> the sun falls on the yellow grasses and the tawny brackens. Plover and curlew and the
> kestrel are the denizens of these wilds. Unfortunately, since Jessica wrote these words,
> almost 70 years ago, the three birds have become less common than they used to be.

Barley village is the centre for walkers who have accepted the challenge of climbing up the Big End of Pendle. Brenda Kean, a friend of mine, was persuaded by her daughter, Helena, to celebrate her sixtieth birthday by climbing the hill from here. After something of a struggle, she found herself at the top surrounded by a number of Asian ladies who looked as if they had put minimal exertion to get there. They had, in fact, walked to very top of the hill in their saris by the easy route from the Nick O'Pendle between Pendleton and Sabden! I have done both and the easy route is now not as easy as it once was.

Barley has the Pendle Inn, the Barley Mow, which is a good restaurant, a splendid little tea shop and, in the car park, a kiosk that serves sandwiches, cakes and drinks, operated on the honesty box principal by the parish council. The building also serves as an information centre, but perhaps the site's biggest attraction is that it is one of the best picnic sites in the north-west of England.

Even on rainy days there are visitors and, in 2011, their numbers were boosted by an archaeological dig at an abandoned seventeenth-century cottage near the Lower Black Moss Reservoir, in which the skeletal remains of a mummified cat were found. This might not have been of much interest if the find had been made almost anywhere else in the country but, in Barley, you are in Pendle Witch Country and all witches had black cats, didn't they?

Visitors assume that the village takes its name from the barley they say was once grown there. Assumptions like this should be made with caution because the derivation of the word barley shows how unlikely the claim is. 'Barley' means 'the bare enclosure'. In other words, the land is unproductive, probably because of the wet clays that are at or near the surface. This is supported

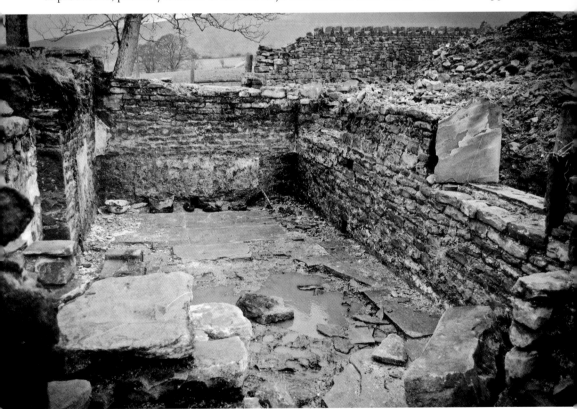

The so-called Witches House, where a mummified cat was found.

The signpost at Happy Valley.

by the history of the place. The village was settled in the thirteenth century as a cow farm cut out of an area used for hunting.

The stream that flows through the picnic site is Barley Water. This joins the Ogden Clough, which is hidden from view as it is almost under the road bridge near the splendid village hall. A little way towards Whitehough and Roughlee is the tiny hamlet of Narrow Gates. What is remarkable about this place is that it is an early mill settlement – one of the few left in the area. The cottages provided homes for the workers in the water-powered mill. The original mill was one of two in Barley. The other was on Ogden Clough at Barley Green. The Narrow Gates Mill, originally described as the New Mill, dates from the 1790s, though it was rebuilt after a fire in 1867. The survival of both cottages and mill is rare.

Whitehough, a lovely hamlet famed for its Outdoor Education Centre, is next on the road to Thorneyholme where there was another mill settlement, which also dates from the 1790s. In 1799, it contained a twist (spinning mill), a new building used as a sizing house and twist room, a warehouse, two farms, a stable, eight cottages, a bakehouse and three 'necessaries'!

Further along, after turning on to Blacko Bar Road at the former Happy Valley tea room, we approach Roughlee, where the first sign of early industrial activity is the unexpected waterfall on White Hough Water. The waterfall powered the Roughlee Cotton Factory, a business on a much larger scale than the water-powered mills we have already met. This mill began in 1787 when Robert Judson, a twenty-one-year-old shalloon (wool) manufacturer of Roughlee, made an agreement with the landowners to erect a cotton mill on what, in the agreement, is called Roughlee Water.

We know what this mill looked like in 1808 when Robert died. It was of four storeys, had ten bays, was topped by an impressive bellcote and had three chimney pots. It measured 86 feet by 36 feet and had both a waterwheel and an 18-horsepower steam engine. Though the mill

Handloom weavers' cottages in Roughlee.

has gone, the millpond is still there and it was used as a pleasure ground early in the twentieth century, one of the most popular in the district.

But Roughlee, with its outstanding Bay Horse Inn, is famed for its association with the Pendle Witches, and one of them in particular, Dame Alice Nutter. You will have passed her on the roadside as you enter the village, as a statue to her memory was erected on the 400th anniversary of the witch trial in 2012. Alice Nutter is the only one of those accused of witchcraft, and paid for it with their lives, to be memorialised in this way. She is not the most famous of the witches – Old Demdike and Old Chattox are far better known – but there is a mystery surrounding Alice that has never been fully explained. It is likely that, given the passage of time, it never will be, but Alice Nutter has interested historians for years. She was not of the same class as the others who were accused. Though not a wealthy woman, she came from a relatively prosperous, landowning family. The Nutters had small estates in the Pendle Forest. There was no reason for her to be associated with the two warring families of self-confessed 'witches' who, as we shall see, eventually brought themselves down.

Why Alice Nutter, a respected member of the community (hence the use of the title Dame before her name) became involved in the witch incident is the question that historians have asked. When on trial at Lancaster, the witches were accused of many crimes, some of which we might find amusing if their situation was not as serious as it became. One of them was attending a coven, a gathering of witches whose purpose was to worship the Devil and his minions, or to call up evil spirits and indulge in licentious revels including intercourse with demons. This is pretty heady stuff and, at the time, the punishment for attending a coven if found guilty was death by hanging.

This does not sound like Dame Alice, but when she was asked about the meeting of the coven, supposedly at Malkin Tower, the home of the Demdikes, she said nothing. In fact, she said not a

word at her trial, though this did not save her. Where was she? What was she doing when others accused her of being present?

The Nutter family have produced a number of distinguished people, and two of them enter our story now. They were the brothers John and Robert Nutter, both Catholic priests and both executed for their beliefs: John in 1584, at Tyburn, and Robert in 1600, at Lancaster. It is known that John suffered to be hanged, drawn and quartered, but could it be that he and his brother were related to Dame Alice? If they were that might just account for Alice's silence. Was she at a Catholic Mass? We have seen what happened to active Catholic priests. Was Alice protecting Catholics, perhaps members of her family and some of her friends?

No one can say for sure whether this was the case or not, but if Dame Alice was acting, as has been speculated, she was not a witch but a heroine. It has been suggested that Alice lived in Roughlee Old Hall and those interested in the Pendle Witches still make their way to the house. However, it has recently come to light that Dame Alice is more likely to have lived near Crow Trees, a property in Roughlee but higher up the valley.

Before leaving Roughlee, we cannot forget Newchurch-in-Pendle, the place where the Witches' Grave can be found. Of course, it is nothing of the kind! Who has ever heard of a witch being buried in a churchyard, and on the sunny south side for all that? There is, however, such a grave, marked with a skull and crossbones and hourglasses to illustrate a point made more graphically here than in many other graveyards. The grave is the last resting place of seventeenth-century Nutters who may or may not have been related to Dame Alice, but the church, founded as the chapel of the Forest of Pendle in the thirteenth century, is worth a visit, as is Witches Galore, the only remaining shop in the village that specialises 'in all things witchy'.

Newchurch is one of the places proposed for the site of Malkin Tower, the home of Old Demdike, the leader of one of the witch clans. A number of places have been suggested but none

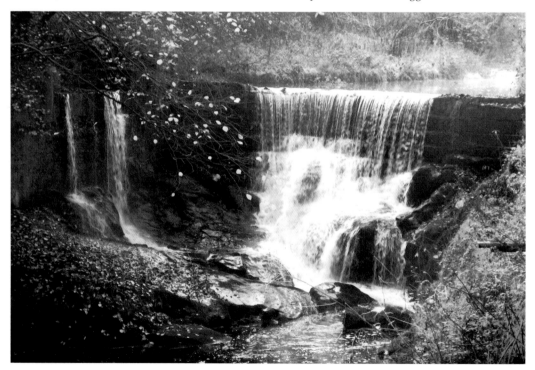

The famous waterfall at Roughlee.

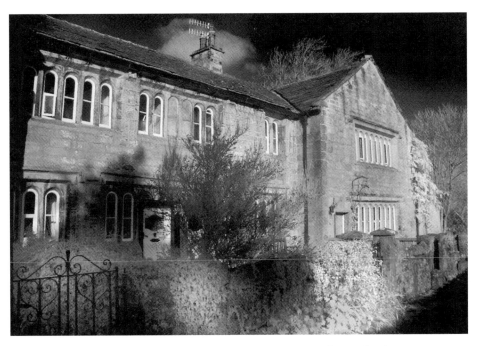

Roughlee Old Hall – formerly believed to be the home of Pendle Witch Alice Nutter.

Witches Galore – for 'all things witchy'.

The Witches' Grave – note the skull and crossbones.

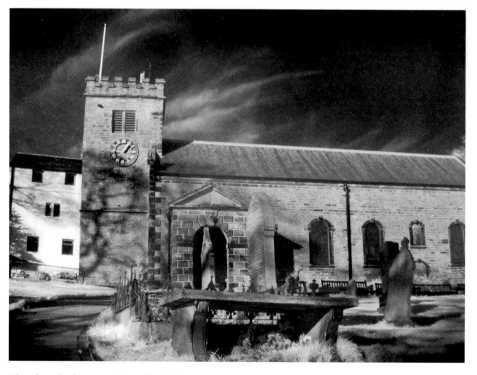

The church that gave Newchurch its name.

have been proved. However, you are on safer ground at the ILP Clarion, to the east of the village. This is the last of its kind in the country, a tea room run by one of the socialist parties that helped to form the modern Labour Party. It has been on its present site since 1912. How many cups of tea have been served here over the years, I wonder?

Pendle Water comes into being after Roughlee and it heads for the Water Meetings with Blacko Water to the east of Hudderston Wood. Mention of Blacko reminds me of Jimmy Clitheroe (1921–73), the man-boy comedian best remembered as 'The Clitheroe Kid' – also the name of a popular radio programme in the 1950s and 1960s – who was brought up in the village. Just outside of Blacko is Beverley where the Cross Gates Inn is located. This inn displays an old sign that states that there will be 'Free Ale To-morrow' but, of course, tomorrow never comes!

Pendle Water does not trouble the Blacko itself but it travels through its own beautiful tree-lined valley, which constitutes a lovely afternoon's walk. The walk is made all the better by a well-cared-for footpath, proving just how necessary council access and footpath officers can be. For some distance, the stream passes over a bed of rough stones and it is very pleasant to hear the energetic waters splashing on their way to the old packhorse bridge at Higherford.

After this it is but a short walk to the Park Hill Heritage Centre at Barrowford, which is based in a house that was once home to the family of Sir Roger Bannister, the world's first four-minute miler. The heritage centre is one of the best of its type in the country and is a credit to John Millar. There is the Crucked Barn, which was originally on the Towneley Estate; a beautifully restored walled garden; local history and art displays; a bookshop and an information centre, but many people visit the building for its excellent catering.

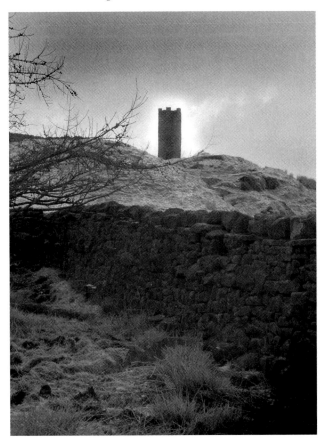

Blacko Tower, wrongly believed to be the home of the Pendle Witches.

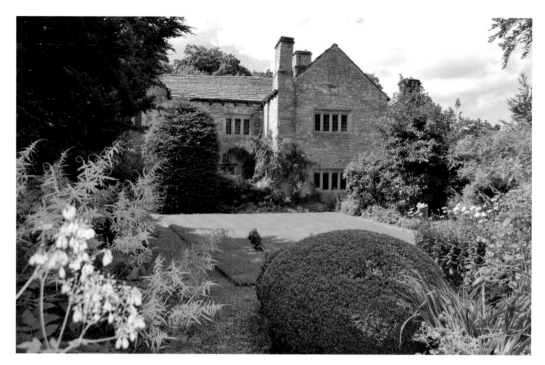

Park Hill, now the Pendle Heritage Centre.

Pendle Heritage Centre in Barrowford Park.

Barrowford Park is nearby and the large village of that name is worth exploring. However, the Ribble Rivers Trust has installed a fish easement and a fish pass to enable fish to get to the higher reaches of the stream more easily. Soon, we are at Lowerford where Pendle Water is joined by Colne Water and we must say something about this watercourse as well.

> Deer once drank at Wycoller Beck and roamed free both in the valley and on the moors, for Wycoller lay in the Forest of Trawden. A forest was then not necessarily all woodland. The Latin meaning of *foris* is 'outside' and the word 'forest' was applied because the land to which it referred was outside the ordinary law. Naturally, as these tracts of land were reserves for the king's beasts, they contained a large amount of woodland, and eventually the word 'forest' became synonymous with 'woodland'.

The words above are taken from John Bentley's *Portrait of Wycollar* and he touches on a subject that has only been referred to in passing so far. East Lancashire was, in the Middle Ages, surrounded by Royal Forests: the Forests of Pendle, Trawden, Rossendale and Bowland. There were also a number of private hunting parks. Those at Hapton, Towneley and Ightenhill are examples. In addition, there were a number of warrens (for the hunting of small animals) and, though not as well known as the forests and parks, they were all areas reserved for the hunt. A good example of a warren is in the Lordship of Briercliffe, which was established by Edmund de Lacy in 1235. There are the remains of a warren – for the breeding of rabbits – in Everage Clough, south of Towneley Park in Burnley.

A forest was a royal hunting reserve, the most famous of which was the New Forest in Hampshire, which was reserved for the pleasure of the early Norman kings. In fact, one of them, William Rufus, son of William the Conqueror, was assassinated while enjoying his privileges there. It is not known whether the kings of England exercised their rights to hunt in any of the East Lancashire forests, but what we do know is that they did not come into royal hands until 1399 when Henry IV came to the throne. He was the son of John, Duke of Lancaster, better known as John of Gaunt, after the place of his birth, but more importantly he was the fourth son of Edward III.

When Henry succeeded, he took the Lancaster possessions of his father to the Crown. These included the hunting grounds of East Lancashire, which previously had enjoyed the status of chases (non-royal hunting grounds reserved largely for the nobility).

All this might seem to be tedious and not very relevant today but nothing could be further from the truth. The chases, forests, parks and warrens of the area existed to produce, as efficiently as possible, animals for the hunt. Of course, the most important were the chases and, later, the forests, but the Towneley's park at Hapton was the second largest hunting park in Lancashire and Hapton Tower, the house at its centre, was favoured by members of the family in the sixteenth century.

The animal the chases and forests were devoted to produce was deer. This took precedence over everything else. The keeping of farm animals could only be undertaken once special permission had been granted and, even today, the location of such farms can be identified in a number of ways. The vaccary walls of Wycollar are understood to delineate the boundaries of farms established, as their name might suggest, for the rearing of cattle. The use of the word booth, in many local place names in both Pendleside and Rossendale, as in Higham-with-West Close Booth, Goldshaw Booth and Roughlee Booth, also indicates early cattle farms carved out of the hunting grounds. Lastly, a number of place names refer to the boundaries set up to prevent farm activities and farm animals getting into the hunting grounds. These include Fence, which is in the civil parish of Old Laund Booth, and Palace House, in Burnley. The origin of the first of these is self evident, but the latter comes, not from a royal house, but the palisade around an early cattle farm.

If you think that the farmers had it difficult, it was much more problematic to develop other resources – coal, timber, building stone, etc. – in the forests. These activities were positively

The war memorial in Barrowford Park.

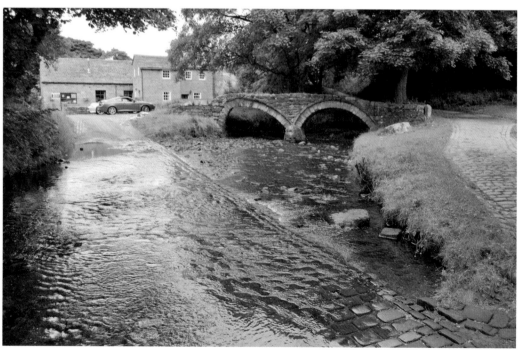

The Packhorse Bridge and ford at Wycoller.

discouraged by the officials who managed the forests. Though it would be true to say that the forests were established on marginal land, the harsh laws that applied to them constrained their economic development. Similarly, the laws relating to poaching were especially cruel, but that is another story.

By the latter part of the seventeenth century, the forests and parks were in decline. There was still hunting, of course, but landowners were beginning to realise that there were sources of wealth other than the hunt.

Wycoller is in the Royal Forest of Trawden, but today the village is visited because of its Brontë associations and its country park. The village contains a number of old houses and the remains of Wycollar Hall, the Ferndean Manor of Charlotte Brontë's 1847 novel, *Jane Eyre*. This house, now romantically in ruins, was the home of the Cunliffe family, several of whom were, as Jessica Lofthouse puts it, 'mad on sports': hunting, shooting and cockfighting. The village also has associations with Emily Brontë's *Wuthering Heights*. The Wycoller Country Park is a delight to visit with its well-maintained footpaths, its ghost stories, the Pepper Hill Barn Study Centre and the Aisled Barn. The latter is worth a visit in its own right, but more so because it acts as a base for the excellent Lancashire Countryside Service and houses occasional exhibitions.

The Wycoller Beck meets the river Laneshaw at Laneshaw Bridge where, on maps, the Hallown and Winking wells are marked. I do not pretend to be expert in the history of ancient wells, but the former interested me initially because of its spelling. We had just celebrated Halloween, a big event in my part of the world, and I wondered if there might be any associations with that notable date in the religious calendar. I was not surprised to find that this had already been suggested. The Hallown Well is situated beside a small fisheries lake in what were the grounds of Emmott Hall. The well, I discovered, had another name, the Saints Well, as in 'All Saints' or 'All Hallows', and it is believed that it was once a place of baptism and may have been so as early as the ninth century. In addition, there is a story that the well was used in the Middle Ages by travellers en route between Whalley and Combe Hill Cross, near Bradford in Yorkshire. It is understood that the well once had healing properties but when I located the site, the water, once crystal clear, was not all that clean.

From Laneshaw Bridge, Colne Water makes its way towards the town, joined by the Trawden Brook at Cotton Tree. Both streams once played significant roles in the early part of the Industrial Revolution, with the former having three and the latter having two mills that worked on the Arkwright principle and powered by water. The building of these mills (in one instance the rebuilding of an old Walk Mill) took place in the 1780s and 1790s. Colne, therefore, has a significant place in the history of King Cotton.

The town of Colne is now much better known because of Wallace Hartley, the hero of the *Titanic* disaster that took place in 1912. The story of the sinking of the 'unsinkable' ship has been told many times in books and films, but the heroic role of Wallace Hartley, the bandleader on board ship who played the hymn 'Nearer, my God, To Thee' as the ship went down, is constant. Recently, the 100th anniversary of the tragic event took place and Mr Hartley was not forgotten in his hometown where, until recently, there was a museum dedicated to telling the story of the sinking of the *Titanic* and where an inn is named after the bandleader. The museum has now moved to Salmesbury Hall, between Preston and Blackburn.

In the past, Colne was a great centre of the wool trade with its own cloth hall, but this has now gone, as has the great house of the district, Alkincoats, which was once the home of Colne's museum. Unfortunately, the museum closed because the penny-pinching council said it could not afford to keep it open. There is, however, enough left of historic Colne to make a visit worthwhile and I have enjoyed tracing the places mentioned in Robert Neal's novel *Song at Sunrise* (also published as *The Mills of Colne*), which uses historical details, often provided by the late Wilfred Spencer, to tell the story of Colne's role during the Industrial Revolution.

Within this town can be found the site of the Greenfield Mill, where Robert Shaw, the hero of the story, is introduced; Wanless Bridge on the Leeds & Liverpool Canal, where barges containing

The village of Wycoller.

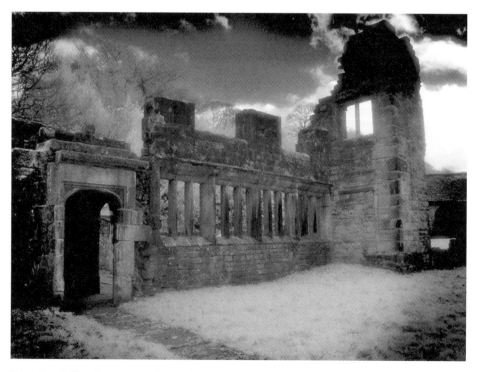

Wycoller Hall – the setting of Ferndean Manor in Emily Brontë's *Wuthering Heights*.

cotton were unloaded; and Cumberland House, now the Union Hotel, but then the home of Nicholas England, the leading manufacturer in town.

Colne Water joins Pendle Water and now makes for Nelson, which was once known as Little Moscow because of its left-wing tendencies. The river passes the site of Seedhill, the former stadium of Nelson FC, once members of the Football League and, in 1923, the first English team to beat Real Madrid in Spain, the final score being 4-2. Nearby is one of my favourite municipal parks, Victoria Park, which is famous for the birds that live on its splendid little lake. Downstream is the Industrial Revolution village of Lomeshaye. The former woollen mill is still there and the workers' cottages are still intact and still lived in, retaining their original street names. There is also a new addition, the Lomeshaye Marsh Nature Reserve, where the Ribble Rivers Trust undertook a successful planting scheme.

Passing to the west of Brierfield, Pendle Water is given the attention of the Ribble Rivers Trust at Montford Weir, which has been removed so that riverine habitats can be improved. The weir's removal provided thousands of tonnes of material for new spawning grounds downstream, and revealed a highly suitable spawning and juvenile habitat upstream.

Soon the river arrives at Holme End in Reedley. These days there is not much to see at Holme End. The nearby Jewel Mill has gone, demolished when the M65 was built, but this area was once home to Jack Moore's Monkey, the name of the pleasure grounds that were once situated here.

The original Jack Moore founded his little enterprise in the first half of the nineteenth century, using a monkey to attract customers. They came all right and there must have been generations of monkeys caged for the delight of visitors who walked down Barden Lane in droves each Easter to see the famous animal.

The simple pleasures of the past no longer apply in these sophisticated days. The river makes its way past New Bridge in Pendle, the site of the Bridge Inn, to Royle, once the home of the Townley's of Royle, and it is there that we will continue with the story.

The Clapper Bridge at Wycoller.

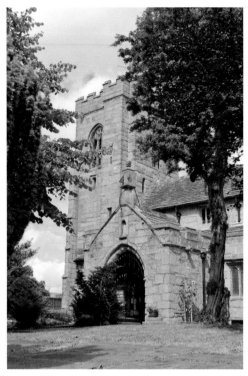

The church of St Bartholomew at Colne.

The old Colne Grammar School.

'The Shuttle' in Nelson Centre.

Bridge House – the former Pendle Bridge Inn.

From the Commerce of Burnley to the Green Pastures of Whalley

As we leave industrial Burnley behind us, the first part of our journey through the valley of the Lancashire Calder is over, but many of the themes we have identified will continue while new ones will be introduced.

Once under the Burnley railway viaduct, which dates from 1848, we are now on what was the Royle Estate. The upper part of it is called Stoneyholme – the 'stoney island' as the Vikings, who settled there over a thousand years ago, called it. This part of Burnley, with no through road, was one of the later parts of the town to develop, though things might have been very different long before the railways came. If the Leeds & Liverpool Canal had been built to its original plan, which would have taken it directly across the valley of the Calder from Barrowford to somewhere near Wood End, access to the canal from the western part of Burnley would have been necessary and development may have taken place sooner.

As it was, the viaduct became a barrier for a generation. There were small developments where communications were good but a postcard view of Stoneyholme, Burnley from the Mitre (*opposite page*), taken in around 1910, tells you all you need to know about the effects of expansion into this part of Burnley at the end of the Edwardian era.

The photograph, upon which the card is based, was taken from the top of a water tower on Padiham Road in Burnley. The view shows the canal with a boatyard and a broad barge of the type once common in this district, smoke pouring from the Clifton Colliery, the terraces of the Stoneyholme district, part of the Burnley Paper Works, the Stoneyholme Gasworks and, in the foreground, the platform of Burnley Barracks with a steam locomotive pulling passenger carriages in the direction of the station. It is possible that the locomotive is the locally famous 'Puffing Billy' (otherwise 'Little Billy'), which ran from Colne to Rosegrove and provided a local stopping service.

It is not possible to identify the Calder in this picture without some assistance. Look at the flat land behind Clifton Colliery, which had the tallest chimney in Burnley, though most of it was below ground. With the aid of a magnifying glass, the land will be revealed as a patch of open property crossed diagonally by a path on which there are several walkers. This is the Stoneyholme Recreation Ground where Burnley FC played their first competitive matches. On the far side of the ground is the course of the Calder, emerging from the impressive viaduct. After this, and still in the picture, the river passes alongside the polluting Burnley Paper Works (formerly a calico printing works), the Stoneyholme Gasworks (which was built between 1881 and 1887) and the mills of Caldervale. Today, virtually all the industry has gone and most of the site is occupied by the new Burnley College buildings and the Burnley Campus of the University of Central Lancashire.

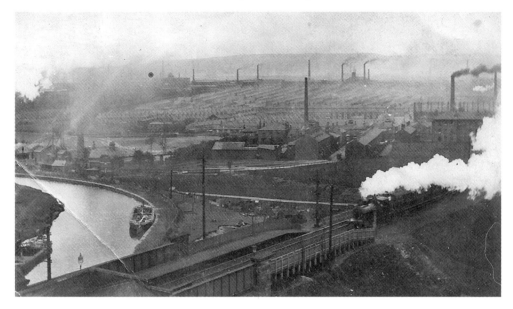

Stoneyholme, Burnley from the Mitre.

From here the valley of the Lancashire Calder opens up and passes the lodge, the entrance to what was the Royle Estate. The hall stood in the valley of Spring Wood, beyond the present Crow Wood Leisure and Equestrian Centre. Andrew Brown, a local businessman, has made Crow Wood a great success. It has facilities for equestrian activities and indoor sport, a spa with a restaurant, a swimming pool and is set in 100 acres of lovely countryside.

Royle Hall was the home of the Townleys of Royle, a cadet branch of the Towneleys of Towneley. The family was descended from Nicholas, the third son of John Towneley of Towneley, whose son, Richard, married Margaret, the heiress of John Clarke of Royle and Walshaw (in Briercliffe), who brought Royle to the family in the later fifteenth century.

There have been several attempts over the years to explain the meaning of the word Royle. Mr Ormerod, in *Calderdale*, suggests that it comes from the Crown's Royal Manor of Ightenhill, which not only included the Royle area but almost the whole of the Burnley district. Others have suggested that the name refers to 'ryelands' (the place where rye was grown), but the most likely meaning can be seen in the spelling of the place name – 'Rohille' – towards the end of the thirteenth century. This can be translated as 'roe hill', the hill where the roe deer could be found. Of course, this fits in with the many place names in the locality that are derived from the area's long association with the hunting of the deer.

The Townleys of Royle did not produce many interesting sons, but one of the few high achievers was Nicholas, the younger brother of Richard, who is thought to have been a chaplain to Henry VIII and clerk of works to the building of Cardinal College, now Christ Church, in Oxford.

The family did not spell their surname the same as the Towneleys of Towneley, dropping the first 'e' to distinguish themselves from their relations. Unlike the Towneleys of Towneley, the Townleys of Royle became Protestants, and two of them – Edmond, a rector of Slaidburn in the early eighteenth century, and Arthur Townley Parker, who held the same position in Burnley throughout the latter half of the nineteenth century – were significant clergymen.

Canon Arthur Townley Parker (1830–1902) was the fourth son of Robert Townley Parker and was appointed Incumbent of Burnley on the resignation of Archdeacon Robert Mosley Master. Both of these men lived in Royle Hall, which in their time was regarded as Burnley's rectory, and

both were highly thought of by local people, no matter their religion. Archdeacon Master came to Burnley from Croston in Lancashire in 1826, at a time of great distress in the town. He was the first curate of Burnley for some time to take much of an interest in his flock, and one of the first things he did was to appeal to George IV on behalf the area's unemployed weavers and their families. The King contributed one thousand guineas to the work of the London committee for the relief of the poor in the manufacturing districts and others soon followed. Little London Farm in Briercliffe, now Sweet Well, was built out of funds supplied by the committee.

Robert Mosley Master was known in Burnley as the 'Clogging Parson' because he set up a clog fund to provide poor children with footwear. On his arrival in town he had been shocked to see the youngest of children, in the coldest and wettest of weather, with nothing to wear on their feet. Other things he achieved included the opening of a town dispensary, the setting up of a savings bank, the opening of the Church Institute, the setting up of the National & Sunday Schools Sick Society, the building of the town's first day school at St Peter's, the remodelling of that church and the construction of several others. All these make Mr Mosley Master someone who should be remembered better than he is and, when I am in the vicinity of Royle Hall and the parish church, I think of him, a man who did immense good in his lifetime.

There was a hunting lodge just beyond the hall at the Water Meetings where the Calder is joined by Pendle Water, and it is here that those who once claimed that the latter is the real Calder have a point. Pendle Water is conspicuously larger than the Calder when viewed from the Water Meetings, and the enlarged Calder becomes quite impressive from here onwards.

The river turns left towards Pendle Hall and Hunterholme on the right bank, and Hunter's Oak and Hagg Wood on the left. The former reminds us of the Lancashire Witches because one of the two main families associated with the story – the Whittles – lived near Pendle Hall. The family was headed by Anne Whittle, 'Old Chattox' in the story. She had two daughters, Elizabeth (Bessie) and Anne, the wife of Thomas Redfern. Both Annes were hanged for their offences.

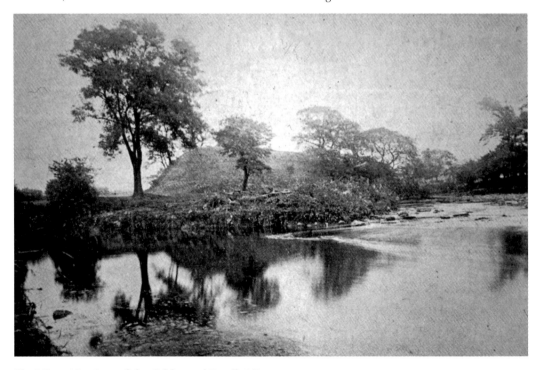

The Water Meetings of the Calder and Pendle Water.

Thomas Potts, who wrote the account of the 1612 witch trial, described Anne Whittle:

> This Ann Whittle, alias Chattox, was a very old withered, spent and decrepit creature, her sight almost gone ... Her lippes ever chattering and walking; but no man knew what.

Anne Redfern was described as 'more dangerous than her mother for she made all or most of the Pictures of Clay, that were made or found at any time'. Elizabeth, or Bessie as she was known, was a convicted thief and it was her spiteful accusations that led to Roger Nowell's enquiry, the case at Lancaster Assizes and the eventual hangings there on the scaffold.

The story of the Lancashire or Pendle Witches is well known, but it is not always appreciated that little would have happened if the Whittles and Southerns (the 'Demdikes', the other 'witch family') had not fallen out. This is more remarkable than might first appear because some of the crimes had taken place twenty years before, and included two murders that had taken place in 1593 and 1595.

The actual incidents that precipitated the story were twofold. The first was a raid on the Demdike property at Malkin Tower, the site of which, as we have seen, is unknown, but likely to have been in or near Newchurch-in-Pendle. Bessie Whittle had stole clothing from the tower and, on the Sunday following, she was seen wearing some of it by Alizon Davies, the granddaughter of Elizabeth Southern, alias Old Demdike. Alizon, only a mere girl, reported the matter to the Greave of the Forest, who then informed the magistrate, Roger Nowell. A hearing was held at Read Hall, Roger's house, in which Bessie is understood to have accused Alizon of being a witch. Alizon, when questioned, implicated her own grandmother and she mentioned a number of other crimes committed by Old Demdike in her capacity as a witch.

The outcome of the inquiry was that Bessie was sent to the Lancaster gaol accused not of witchcraft but of theft. Alizon was not arrested but she was involved in an incident that had dire repercussions just five days later. Alizon was sent to Colne market by her grandmother to beg and it was in the capacity of a beggar that she approached John Law, a Halifax pedlar, asking him to sell her some pins. The pedlar must have known about the Demdikes so he told the girl to be off, as he did not want his pack stolen. At that, Alizon cursed the pedlar who, within a few minutes, had a seizure and fell to the ground. Law was taken to an inn at Colne where, shocked at what she thought she had done, Alizon visited him. Later, the pedlar's son, Abraham, arrived from Halifax, and his father, having recovered a little, was able to say that he had been bewitched.

Alizon was taken to Read for examination and the evidence she gave, together with that from other members of her family, given at Fence and elsewhere, convinced Roger Nowell that there was a case to answer and that it should be decided at Lancaster Assizes. The most sensational accusation was that the 'witches' had met at Malkin Tower on Good Friday and had held a meeting with the Devil.

Four hundred years later, the witch trial and the witches themselves are still being talked about. Every year at Halloween, local residents and visitors remember the event. There are a number of novels about the story, the best of which remains *Mist Over Pendle* by Robert Neil, and there is a witches trial that can be followed by those who want to find out more.

The main source for all the books written about the Lancashire Witches is *The Wonderful Discovery of Witches* by Thomas Potts, the clerk of the court at Lancaster. Usually, legal records of trials consist of little more than an accusation, the name of the accused and the decision of the court. But Potts had written a detailed account that tells much of the story, though there are occasions when one would have liked the author to go into more detail. At the time of its publication, the book inspired several plays performed on the London stage. Some have claimed that it may have influenced William Shakespeare but, although the playwright is understood to have spent time at Hoghton Tower in Lancashire, it is unlikely.

The conclusion must be that the witch trial took place in a period of religious upheaval, at a time of great illiteracy and when even the king feared the power of witches. Is it not surprising

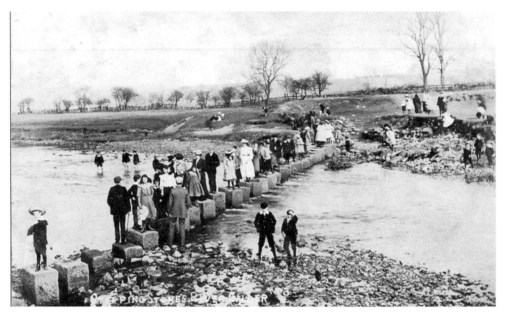

The Calder Stepping Stones at Ightenhill.

that his local agent, Roger Nowell, did such a thorough job in the prosecution of the witches. Recently, there have been calls to pardon these ignorant women. That a pardon has not been forthcoming probably says more about our time than theirs.

We have to move on to Ightenhill, which, incidentally, saw another outbreak of witchcraft in 1633. Ightenhill Park, to give the parish its proper name, contains the site of the medieval manor house of the Burnley area. It was also the place from which the forest laws were imposed. Little remains of the site these days, but the parish council has been making every effort to get the site interpreted. The trouble is that the building, which dated from the twelfth century, was in ruins by the early sixteenth century. Its functions were transferred to St Peter's church in Burnley and the courthouse in Higham, on the other side of the Calder from Ightenhill, as early as 1523.

Higham is certainly worth a visit. It was the birthplace of Sir Jonas Moore, one of the more significant English scientists of the seventeenth century and the founder of the Royal Observatory in Greenwich. What is not usually appreciated about him was that he was born in 1617, only five years after the witch trial, and that his parents and grandparents were involved in the events of 1612. Higham was also the home of the handloom weaver William Varley, whose diary and account book cover the years immediately after the Napoleonic War and constitute important sources for local historians. The village has a number of cottages associated with the handloom industry, and it is also the home of the Four Alls, the very friendly but haunted village inn of 1795. On its sign are the images of a king (who governs all), a soldier (who fights for all), a clergyman (who prays for all) and a poor labourer (who pays for all)! This might have something to do with the fact that in the past Higham was a centre of Chartist activity. The Chartists were radicals of the 1830s and 1840s who campaigned, and sometimes fought, for the Charter. The Charter listed among its six points, universal manhood suffrage, annual Parliaments and payment of MPs. It has been observed by some that the latter has got a bit out of hand in recent years!

The courthouse still stands in the village, but there are other treats for us to discover. The old Pinfold still survives, as does a water trough built for the packhorses of a bygone age and, around the corner from the latter, is the village pump that until recently supplied the purest of spring water. The pump was so well known that, a few years ago, Brenda Kean and I found an American

Higham's Four Alls Inn.

lady who had travelled from Preston to collect Highham water for the elderflower champagne she was planning to make.

From Higham there is a footpath that leads to High Whitaker, the place from where the family of Dr Thomas Dunham Whitaker derives. Nearby is Hargrove, in its day an even more remote property. It was here, legend has it, that a post-Reformation Catholic seminary was founded. This story has always intrigued me, but little is understood about the nature of the work undertaken at Hargrove, or indeed if any was, but it is supposed that a seminary, or school, for the sons of Catholic gentlemen was run from there after the founding of Burnley Grammar School in 1559. There had been a school at St Peter's since at least 1322, and it had been responsible for training boys to sing at the services at St Peter's. It has been described as a 'song school', but, doubtless, the boys also had a rudimentary education.

When the grammar school was founded, the role of its predecessor came to an end and it is supposed that the Catholic 'seminary' was commenced in this remote house. More work needs to be carried out on this but if there was such a seminary at Hargrove, it would explain the large number of Burnley boys who entered the Catholic priesthood and why so many suffered for their faith in those penal times. A little supporting evidence has been found at the house. A Catholic priest visited the site early in the last century and was shown the shaft of an old Catholic cross that had been in front of the house. It had been used as a gatepost but, when raised, it was found to have a carved monogram with the initials 'IHS' on the square base. This might not prove anything. However, the 'gatepost' might have had significance for those families who may have supported the work of a seminary or school attempting to fill the gap created by the founding of the grammar school.

Now we turn to Gawthorpe Hall, and we should get one thing straight from the outset: Gawthorpe is not, and never has been, in Padiham. The house is in Ightenhill, as is much of its park. The name Gawthorpe means 'cuckoo farm' and it was the home of the Shuttleworths for well over 600 years. The building started as a pele tower but, at the beginning of the seventeenth

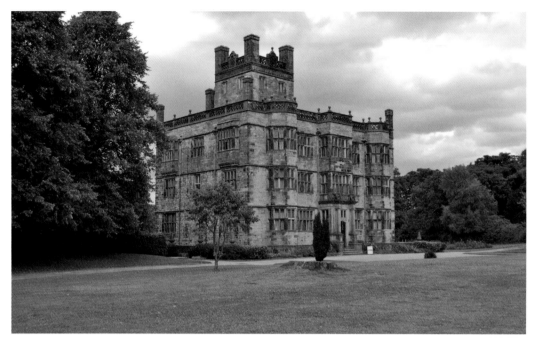

Gawthorpe Hall, the home of the Shuttleworth family.

century, the house was substantially enlarged. It was remodelled in the 1850s by Sir Charles Barry, the architect of the Houses of Parliament. The house has been in the hands of the National Trust since 1970 and it now contains the magnificent Rachel Kay-Shuttleworth Textile Collection, which was built up by the last resident of that name.

In addition to Miss Rachel, the Shuttleworths have produced a number of interesting family members. Colonel Richard Shuttleworth was the commander of the Parliamentary forces in the Blackburn Hundred during the English Civil War and we will be meeting him when we find ourselves in Read. However, the most outstanding member of the family was not born a Shuttleworth, but was a member of the Kay family of Rochdale. This was Sir James Kay-Shuttleworth (1804–77), the social reformer. In 1842, he married Janet Shuttleworth, who had succeeded to the family estates at a very early age, and the family name was changed to Kay-Shuttleworth at that time.

When still a young man, James Phillips Kay was employed in the Rochdale Bank. In 1824, he became a medical student at Edinburgh University and returned to Manchester in 1827, where he was instrumental in setting up the Manchester Statistical Society. He worked in the Ardwick & Ancoats Dispensary, and while there he wrote *The Moral and Physical Condition of the Working Classes Employed in the Cotton Manufacture in Manchester*. The book was quoted by Engels and had a considerable impact on the government of the day, and for years to come.

In 1835, James was appointed Poor Law Commissioner for Norfolk and Suffolk and, later, for London. This was after the passing of the 1834 Poor Law Amendment Act, a regressive piece of legislation that did not sit comfortably in the reform era of the 1830s. In 1839, he was appointed the first secretary to the Committee of the Privy Council, which was responsible for making grants for the furtherance of public education. The first grant had been made six years before and the two developments, taken together, changed English education and how it was delivered forever. Another of James' achievements was the establishment of the Battersea Normal College in 1840, the first teacher training college in the country. In this he was supported by Janet

Shuttleworth, who was soon to become his wife. Miss Shuttleworth had already established a school on the Gawthorpe Estate.

In 1849, James became Sir James and he spent his later years in public service, being much involved with national efforts to relieve those affected by the Cotton Famine of 1861–65. In 1864, Sir James was High Sheriff of Lancashire. He also published two novels, *Scarsdale* (1860) and *Ribblesdale* (1874), and one of them gives details of the last days of the handloom weavers.

Sir James' oldest son, Sir Ughtred James Kay-Shuttleworth, became MP for Hastings from 1869 to 1880, and then for Clitheroe from 1885 to 1902. He was a member of Gladstone's third and fourth administrations, holding the offices of Under Secretary of State for India, Chancellor of the Duchy of Lancaster and Secretary to the Admiralty. In 1902, he was created Baron Shuttleworth. This necessitated his resignation as an MP, which was followed by one of the most bizarre by-elections held in this part of the world.

Briefly, there were four candidates, but three of them withdrew sensing the popularity of the Labour Representation Committee candidate, David Shackleton. David was born at Cloughfold in Rawtenstall and was an official of the Cotton Weavers' Union. Philip Snowden, later the Chancellor of the Exchequer, who had been approached to stand for the Independent Labour Party at the election, was the first to withdraw, and he was followed by both the Liberal and Conservative candidates. David Shackleton, therefore, was elected unopposed, becoming the first English Labour MP.

This story, remarkable as it is, might need some explanation for those not familiar with our local political history. Despite the 'Little Moscow' epithet attached to Nelson, Burnley, because of its association with H. M. Hyndman and the Social Democratic Federation, is often thought of as the local home of Socialism. In fact, the first translation into English of Marx's *Communist Manifesto* was undertaken by a Burnley woman, but Burnley did not get its first Labour MP until 1918.

David Shackleton's success in 1902 is all the more remarkable when one considers the nature of the constituency he won. Though it contained some towns, like Clitheroe and Padiham, it was largely rural. In recent years, Clitheroe, now known as Ribble Valley, has been just about the safest of the Conservative seats in the sub-region. The result of 1902 must have been something of a shock. But perhaps it says much more about David Shackleton who, in his time in Parliament, became the chairman of the Parliamentary Labour Party, was invited by Winston Churchill in 1910 to join the Civil Service, and also became the first permanent secretary at the new Ministry of Labour – the first working man to hold such high office.

At Padiham, the Ribble Rivers Trust has been working on the site of the weir that once captured water to supply the cooling towers of the former Padiham Power Station, which occupied the site of the present Shuttleworth Mead. Steam turbines were used to generate electricity in the coal-fired power station. However, the weir prevented the migration of salmon upstream and the Trust has lowered the weir and replaced it with rock ramps that ease the passage of the fish. In recent years, fish have returned to the reaches of the river above the weir, and visitors, such as heron and dippers, have increased. The weir predated the power station and may have provided water to the former Simonstone Paper Works.

The area from Gawthorpe to Whalley is one of the most beautiful stretches of the Lancashire Calder. This is partly because of the survival of so many of the old landed estates. These comprise Gawthorpe, Huntroyde, Simonstone, Read, Clerk Hill and Moreton. The area around Worksop in Nottinghamshire is known as 'the Dukeries' because of its ducal estates and I have often thought that there ought to be a collective noun for the part of the Calder valley that we are about to enter.

First, however, let me take you to a few of my favourite spots in an area that has so many. The first is in Simonstone, which has been called 'Burnley's Stockbroker Belt' and was mentioned on *Antiques Roadshow* by local man Eric Knowles. A visit to Simonstone will confirm what he means. The village contains a number of splendid, older houses, a number of more modern,

architect-designed houses, the charming little church of St Peter's, the big houses at Huntroyde, its park, known as Huntroyde Demesne, and Simonstone Hall.

However, don't get the impression that there is no industry in Simonstone – the village once had a paper works, the site of which is adjacent to the Calder. In more recent times, a number of large companies were allowed to build factories here, including one by Mullard, later run by Philips, which made televisions and television screens. Needless to say, the paper works has gone – replaced by a transport company – as have most of the new companies that came to Lancashire's Calderdale in the 1960s.

The little spot I want to take you to is at Gooseleach Lane, which is off Simonstone Lane in the village. The name indicates that the land here was once pastured by geese, the 'leach' part coming from 'lecche' – a stream. There are lots of 'lecche' names in this part of the world and, as there will usually be a stream nearby, you can be sure that it will flood regularly, or that the land around will be very wet. All of these are true of this area but is not noticed by many. A regular, and often muddy, walk takes me to Gooseleach Wood, which is divided into two parts by the old Great Harwood Loop railway line, closed by Dr Beeching in the 1960s, though the station in Simonstone had its last passengers in 1957.

In recent years, there has been speculation that this part of the parish, along with land in neighbouring Read and Altham, are to become a horseracing track. A consortium, headed by the Marquess of Zetland, has looked at the site and a planning application has been considered, but there has been lots of opposition and it might not happen. However, locals are mostly unaware that Lancashire's Calderdale had at least three racing venues up until the mid-nineteenth century. The one in Padiham, on land just to the west of here, was the last to close in the 1860s. The other two were in Burnley, and one of them gave its name to Turf Moor, Burnley FC's famous home.

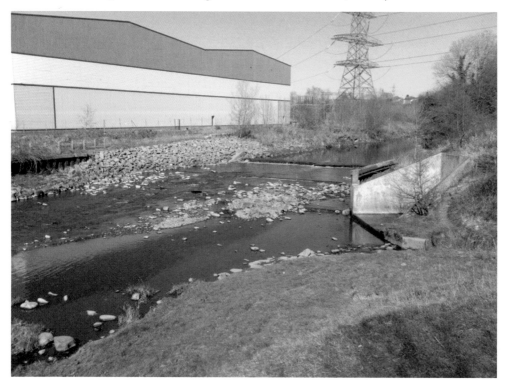

Padiham weir after construction of the rock ramp.

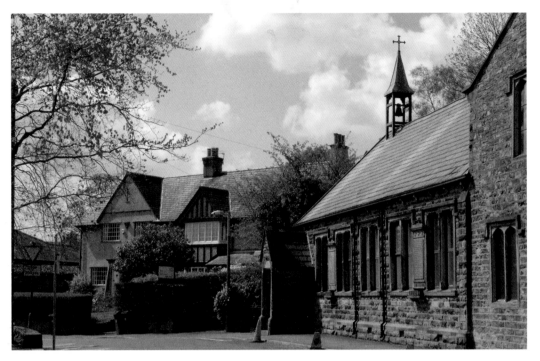

Simonstone School, now St Peter's church.

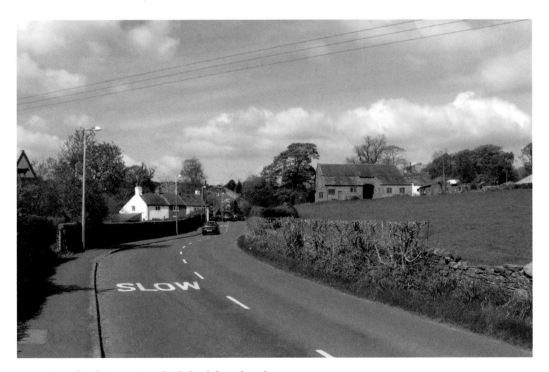

Gooseleach Lane is to the left of the white house.

Another of my favourite sites is in Altham, a village that has changed much over the years because of the building of an industrial estate on its doorstep. However, the village church, in its huge churchyard, is a delight. It is understood that the church, which is dedicated to St James and is the mother church of Accrington, was founded in the twelfth century. It was rebuilt in the sixteenth century, though the building had further attention in the mid-nineteenth century when the chancel was rebuilt, the nave and aisles were restored and the tower was built. There is an ancient piscina or water drain in the church and the font dates from the early sixteenth century, a gift of John Paslew, the last Abbott of Whalley.

Though there is interest in other aspects of the church, the chancel window is of interest to me because it commemorates John Hacking, the inventor of the cotton carding engine. On the south side of the church there is a memorial stone to Mr Hacking, who did not benefit from his invention as much as he might have done. The principles of his design were incorporated into Sir Richard Arkwright's machine and Sir Richard put his adaption to use, making a fortune from this and other 'inventions'.

Almost opposite the entrance to the churchyard is a collection of buildings not often noticed by those passing along the old turnpike road. The buildings constitute an example of an early industrial community with the Altham Corn Mill at its centre. There is a date stone on the mill that tells us it was 'Erected by E. Topham Esq in 1816'. The mill was initially water powered, the power coming from the Calder, though there is a small stream nearby, called the Shorten Brook. A large weir was built opposite the T-junction formed by Simonstone Lane and the turnpike road, and the remains of a mill race from the weir to the mill could still be identified until quite recently. The mill produced corn until the mid-nineteenth century. Later, it became an ice works and, from 1906 to 1947, it was what was known as a 'reed and rib' mill, making the casings for reeds and healds for the cotton industry. Now the mill is the home of Altham Oak, a firm that specialises in bespoke artisan carpentry – a gratefully received donation from them helped to set up Trees for Burnley, which was responsible for the outstandingly successful Forest of Burnley Project.

Only a few hundred yards away to the west is the Walton Arms, an inn that took advantage of the building of the turnpike in the eighteenth century, which is now Blackburn Road. The inn took its name from the Waltons of Marsden Hall in Nelson, who became Lords of the Manor of Altham, and was a refuge for travellers who had business between Blackburn and Burnley. At the time, the area was infested with footpads (highwaymen without horses) who would lay in wait for those who might have money in their pockets.

In this part of the world, footpads, who mainly operated at night, were called 'owlers' and there are a number of streets named after them in the area, but not here in Altham. Perhaps modern residents want to forget their criminal ancestors? On the other hand, the activities of owlers were not restricted to Altham. In the past, the village was just about remote enough for the owlers to operate without too much interference from the law.

One thing that people from Altham cannot forget is the great Moorfield mining disaster. On 7 November 1883, an explosion in the underground workings of the pit claimed the lives of sixty-eight men and boys, while many more died in later years as a result of their injuries. The mine was situated at Pilkington Bridge, where the Leeds & Liverpool Canal passes under the turnpike. What horrors were seen on that day will not to be described here, but a memorial listing the names of the victims, some only at the beginning of life, has been erected to their memory. It is made, most appropriately, out of the material for which this area is world famous: Accrington brick.

Before we leave Altham, it might interest you to obtain a detailed map of the Altham area. I have the 6 inch to the mile map that was revised in 1909. It shows all the sites I have mentioned, and many of the coal mines of the area are also indicated. There are lots of them and I have visited quite a number, especially those in Altham Clough Wood, which can be accessed from Syke Side – another place that holds interest for me because it was here that the Machine Rioters of early industrial days met to plan their machine-breaking activities. Also, the map shows where

The Jessica Lofthouse bench at Read Old Bridge.

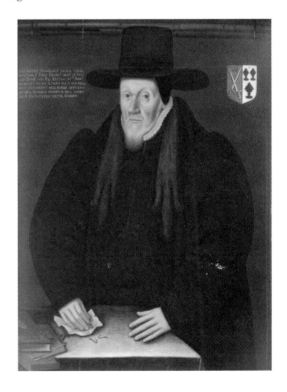

Alexander Nowell is one of Read's most famous sons.

the Hyndburn Brook joins the Calder at a site between Clayton Hall and Martholme. Strictly, we should follow the brook, as we have the other main streams of the area, but somehow Accrington does not seem to be part of this story. Perhaps I am wrong?

The last of my favourite sites in this part of the Calder can be found at Read Old Bridge, which is on the northern edge of Read Park. Read New Bridge is much better known these days, largely because it is close to the Devil's Elbow, a wicked bend in the road that has now been smoothed out a little.

Read Old Bridge on Sabden Brook is a special place not only for me but for Jessica Lofthouse also, who has, in a very real sense, been our guide on our journey through the valley of the Calder. In fact, so significant was this place for Jessica that she had a bench placed by the bridge so that other people could enjoy the spot that had so enthralled her. It is one of several surviving benches that were placed in locations Jessica really enjoyed. Another is in Little Mitton, in the Ribble Valley.

Jessica asks us to 'sit on a grassy bank ... the brook below us and think of the old days and "battles long ago". Let imagination have play; people the scene with our predecessors'. A difficult challenge, but Jessica proves that she is equal to it and soon,

> Travellers pass over the stream, a flow of them, early dwellers whose feet and herds trampled down the ancient road behind Cobcar; Romans from the camp at Portfield, not much more than a shout from where we are sitting, soldiers passing from the camp (now lying between three roads) over the hills towards Colne. From the procession of soldiers and county folk crossing the brook there are some faces we see more clearly. Two lads come racing pell-mell to the water-edge; they are down in a moment, rolling off their long hose and then wading in the brook, silently working upstream, bending over the boulders, fingers probing beneath the stones, employed in the ancient art of "tickling for trout".

The boys are the brothers Alexander and Lawrence Nowell, the two oldest sons from John Nowell of Read's second marriage to Elizabeth Kay of Rochdale. Mr Nowell died in 1526, but these boys both became great scholars and churchmen – Alexander became Dean of St Paul's and Lawrence became Dean of Lichfield.

Alexander, who was born in either 1507 or 1508, was not popular among Catholics and, during the reign of Mary I, he had to leave England for the Continent, where he was much influenced by the European Puritanism of the period. He returned on the accession of Elizabeth I, submitted to the Church Settlement and was appointed Dean of St Paul's. He was also rewarded with the Archdeaconry of Middlesex and a Canonry at Canterbury.

Alexander Nowell was undoubtedly one of the great churchmen of his age. He is thought to have been the author of the Catechism included in the prayer book, but he did have at least two famous disagreements with Queen Elizabeth. On one occasion, when he was preaching, Elizabeth was in the congregation and she interrupted him to tell him to stick to his text and to cease slighting the crucifix. Another occasion saw him present a copy of the prayer book to the Queen but, on opening it, Elizabeth noticed the pictures of saints and angels and told Alexander that the book smacked of the Church of Rome!

However, Alexander survived and he is credited with the invention of bottled beer, unlikely as it may seem. This was the result of an accident where, out fishing, he put a bottle of beer he had taken with him for refreshment in the stream to cool. So interested was he in the fishing expedition that he forgot about the beer. However, at the same spot almost two weeks later, he remembered the bottle and, opening it with a bang that sounded like a gun, as he described it, the beer tasted much better than he had expected. Of course, the beer had been subjected to secondary fermentation, but Nowell told his friends about what had happened and he is thus credited with the invention of bottled beer. Most accounts of this incident are given as taking place in Hertfordshire, later in Alexander's life, but it has been speculated that the invention

actually took place in the waters of Sabden Brook when he was a boy, the beer coming from the brewery on his father's Read estate. Incidentally, there is a bottled beer, called 'Nod to Nowell', which is brewed in Middleton, near Manchester, where Alexander went to school.

The nephew of Alexander and Lawrence Nowell was Roger Nowell of Read Hall, the magistrate who prosecuted the Lancashire Witches. He, along with Thomas Potts, the clerk of the court at Lancaster Assizes and author of the famous trial book, were regarded by many as two of the most notorious 'witch-finders', of which there were a number in penal times. Some of you will remember the 1968 film *Witchfinder General* starring Vincent Price. This followed the horrific exploits of one Matthew Hopkins in East Anglia. Although things can't be said to have been all that civilised in Lancashire, the population of the county were not subjected to the excesses shown in the film.

Read Old Bridge and the valley in which it is situated is described as the Boggart's Glen in Harrison Ainsworth's *The Lancashire Witches*. It is a fiction created by the author but, if we move forward to 1643, the bridge is witness to another incident, the Battle of Read Bridge. As with many of the Civil War conflicts, accounts of the battle are quite confused. The incident is best seen as a small but significant part of the Civil War in Lancashire. The salient points are that, as with the rest of the county, the local families divided themselves between Cavalier and Roundhead: the Towneleys, the former, the Shuttleworths, the latter. At Whalley Abbey there was what we would call an arms dump – the weapons taken from local Catholics by superior Parliamentary forces. The Catholics, under Sir Gilbert de Hoghton wanted the weapons back and the Royalists organised an attack on Whalley.

Richard Shuttleworth was ready for them and, at Henfield (now Enfield) Moor, he put the Royalists to flight with minimal, if any, losses on either side. Sir Gilbert returned to Hoghton Tower where he was soon under siege and he had to vacate his fortified home. There was a huge explosion, still unexplained, in the tower when the Parliamentary forces were in possession.

In April 1643, the Earl of Derby (for the King) advanced on Whalley Abbey with the intention of marching to the east, possibly into Yorkshire, but Richard Shuttleworth was made aware of the Earl's intentions and, against his better judgement, he agreed to surprise the enemy at Read Old Bridge, the only route from Whalley to the east. Parliamentary soldiers were hidden among the trees close to the narrow road. It was the perfect place for an ambush and the Royalists fell into the trap. How many were killed at Read Bridge is not known, but there is a tradition that the slain were buried at Hammond Ground in Read Park. The outcome of this conflict was that Lancashire, despite the support in the county for the king, was lost to the Crown.

Before we leave Read Old Bridge, there is one phenomenon that should not be omitted. It can't be seen on every visit, but when there has been a heavy fall of rain you might feel a bit giddy. The Sabden Brook flows to the south-west, first under Read Old Bridge, then via the Sagar Heys Plantation to Read New Bridge. However, back at Read Old Bridge, a small stream that runs only a few yards from Sabden Brook through Brocklehurst Wood flows to the north-east, which I find somewhat disconcerting.

In Brocklehurst Wood, which is very wet and much overgrown, there are some scattered stones, which are the remains of the Read Corn Mill. Fortunately, the Revd Ormerod included a photograph of Read Old Bridge in his book. The image was taken from the south side of the bridge and, through its single arch, the mill can be seen, roofless but still there. It is the only picture that I have seen of this old water-powered mill.

The Sabden Brook is another delightful stream. In fact, it is currently the only tributary of the Calder with a population of spawning salmon. The Ribble Rivers Trust has been working in the valley and has enhanced off-stream spawning channels to increase the number and variety of suitable spawning conditions for both course and migratory fish. It is understood that migratory fish can detect the suitability of a brook for spawning habitat from several miles downstream. With adequate flow through new channels, natural pools and riffle sequences have been formed and gravel beds have been created for the actual spawning.

Read Corn Mill through Read
Old Bridge.

If we could follow the course of the Sabden Brook, we would arrive at the fascinating but remote village of Sabden – 'the valley where the spruce trees grow' – which derives its name not only from the stream, but from the Sabden Bridge in the middle of the village. Sabden remains a good name, as there are still a number of spruces in the valley but, unfortunately, there is no direct path from Read Old Bridge along the banks of the stream to the village. However, from Cobcar Nook, at the road junction in the direction of Read, there is a narrow lane that takes the careful walker all the way to Sabden. It passes some caves, which existed at the time of the battle, and a short stretch of Roman road before it reaches the woods at Shady Walks and Robinson Wood. A few yards more and you are at Black Hill Crossroads, once the site of a little cottage. From here, there is a lovely walk, with fine views of the Pendle villages and downhill to Sabden itself.

Sabden is particularly associated with Richard Cobden (1804–65) who was born near Midhurst in West Sussex. His early life was one of poverty, and he was sent to live with a Yorkshire uncle who treated him badly. Richard had little schooling but, at the age of fourteen, he was appointed a clerk in the textile industry. A year later he was a textile traveller and, at the age of twenty-four, he became the London agent for Fort Brothers, the Sabden calico printers, along with two partners. In 1831, the partners leased the Sabden calico printing works off the Fort Brothers and soon the new firm had its factory in the village and offices in London and Manchester. Cobden had the management of the Manchester office and he made his home in the city in 1832. A new partnership included George Foster, previously a manager for the Forts.

The firm prospered and Cobden was able to travel extensively in Europe and America. He published a pamphlet in 1835 called 'England, Ireland & America'. This warned about America's latent economic power, was critical about British policy in Ireland and advocated free trade, low taxation, a reduction in military spending and investment in education. He was also part of the campaign for Manchester to get its own democratically elected local government and he was one of the city's first Aldermen.

In 1837, the Anti-Corn Law League (ACLL) was founded in London and, a year later, the Manchester branch was started, with Cobden prominent among its members. It was this organisation that made Cobden's name. The ACLL worked for the abolition of the Corn Laws of 1815, which kept the price of foodstuffs high to the benefit of landowners despite many people suffering. The organisation was also one of the pioneers of Free Trade and, because of his role in the success of 'the League', as it was known, Cobden carved out a successful parliamentary and political career for himself while remaining loyal to his principles at the same time.

Sabden was the place in which Cobden commenced his successful political and humanitarian career. A relatively shy man, he was not a good public speaker at the outset, but in Sabden and Clitheroe he outlined his plans for public improvement. One of his first acts in the village was the financing of a library and in 1836/37, together with George Foster, he established the first school in the whole district that was free from sectarian bias, making Sabden a pioneer in the education of children. The construction of Dial Row on Whalley Road in 1837 was also a successful experiment in encouraging principal workpeople to purchase their own houses rather than rent them, as was the norm. Cobden and Foster made finance available, at a charge of 5 per cent, and the workpeople paid off their loans on a regular and agreed basis.

When in Sabden, Cobden stayed at The Whins, the home of his business partner, but as he became more committed to the ACLL his association with Sabden was necessarily curtailed, lasting only until 1839. In that short space of time, a period of eight years, he made a great contribution to the village. Unfortunately, there is little to remind us today of the work of Richard Cobden in Sabden. Perhaps there should be.

If the village is mentioned today, it is not of Richard Cobden that you will hear but of the 'Sabden Treacle Miners'. In the latter part of the twentieth century, Sabden's treacle mines were very famous. In 1996, a children's television series, telling the stories of the miners, treacle-eating boggarts, parkin cake weavers and black pudding benders was broadcast. The village even had a visitor attraction dedicated to the miners but it was, of course, a huge good-natured hoax.

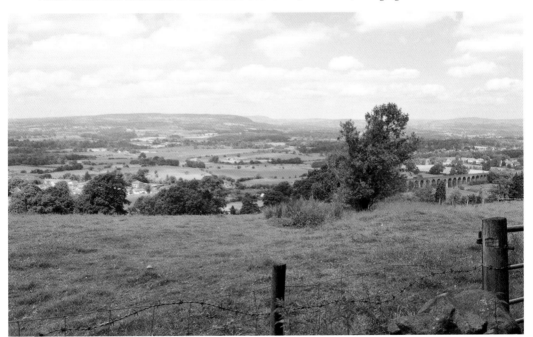

Ribble Valley from Whalley Nab.

Sabden, however, is not the only place to be associated with treacle mining. Treacle mining is known all over England. When undertaking some research for a book, not on treacle mining I hasten to add, I stayed in a hotel in Tadley, Hampshire, called The Treacle Miners. Also, where there are supposed treacle mines, there have often been holy wells – the word 'treacle', in its medieval sense, meaning 'healing fluid' – so Sabden's association with treacle mining might not be as eccentric as you may think.

We are on our last leg because we are about to enter Whalley. The Sabden Brook flows south and arrives close to Cock Bridge, where it is accepted by the waters of the Calder. Dean Brook soon follows and the Calder rounds Moreton Park on its way to the village and the much photographed Whalley Bridge. There is a path that will take you this way. It starts just below the Cock Bridge Inn, now the Moorcock. There are two alternatives: follow the path to the river and on to Whalley Banks, Nab Wood and the delightfully named Marjorie, a row of attractive cottages close to Whalley Bridge. Otherwise, from near the Moorcock, proceed as before to the river, but once past Egg Syke, which is on your left, turn left and take the path to Dean and then Dean Bridge, following Dean Lane and Whalley Banks, as above. Both routes take you below Whalley Nab, a large picturesque wooded hill, 607 feet high and a landmark in the area. In 1897, Whalley Nab was the scene of a huge bonfire that was made to celebrate Queen Victoria's Diamond Jubilee, but it has been claimed that the Nab also saw the hanging of the last Abbot of Whalley, John Paslew. He was declared to be a traitor for his involvement in the Pilgrimage of Grace (1536), which was probably the most serious of the rebellions against Henry VIII. However, the claims that the abbot's hanging took place at Whalley Nab are unlikely. At the time, Thomas Talbot, of Salesbury near Blackburn, stated that 'on Saturday 10th March 1537 there died then Sir John Paslew, Bachelor of Theology, the twenty fifth and the last abbot of the House of Whalley'. The trial, which took place in Lancaster, had been on the 9th, so there would have been no time to make the journey to Whalley for a hanging to take place there on the 10th.

When you are in this area, you might think of climbing the Nab for the splendid views it affords, or better still, make your way along the Whalley Old Road to the little village of York and the Lord Nelson where there are even better views of a large part of both the Calder and Ribble valleys. If the former, take Shawcliffe Lane opposite Whalley Bridge and, after a short walk, there is a path on the right that leads up to the Nab. The alternative is to follow another lane that starts at Painter Wood. This is the Whalley Old Road, a typical example of an early highway and one that took the high route to Blackburn. The road predates the coming of the turnpikes.

York is some distance along the road and is above the larger village of Langho, believed to be the site of the Battle of Billington, which took place in 798. In the battle, Eardwulf, the king of Northumbria, defeated a nobleman, Duke Wada, who is claimed to have been the founder of the delightful village of Waddington, which is a few miles away. On a fine day, the views from the Lord Nelson are spectacular and, with a pair of binoculars, much of the valley of both the Calder and the Ribble is laid out before you ... and you can do this from the bar in the pub!

Whilst here, however, there are easier ways to get to it, and we should not forget Bowley Camp. It is on Dean Lane, though at the Great Harwood end. Great Harwood is just over the hill from York, but if you want to visit the camp, it would be better to approach it from the vicinity of the Moorcock. The 47-acre Bowley Campsite & Activity Centre, which is set in beautiful countryside, is owned and run by the Scouts, though schools and colleges can hire its facilities. I first became aware of it when I was invited to an event at Christmas in 2005. It was one of the most enjoyable occasions of the year and I have returned to Bowley several times since.

I have made the assumption that the ecclesiastical importance of Whalley is widely known. The village contains the extensive ruins of the Cistercian Abbey of Whalley but, long before the abbey arrived at the end of the thirteenth century, Whalley was the centre of a great parish that contained nearly the whole of the valley of the Lancashire Calder. This meant that all of the 'churches' we have mentioned so far were not in fact churches at all but chapels. These include Burnley, Padiham, Newchurch-in-Pendle, Holme, Altham, Colne and many others. Similarly,

The Lord Nelson in the village of York.

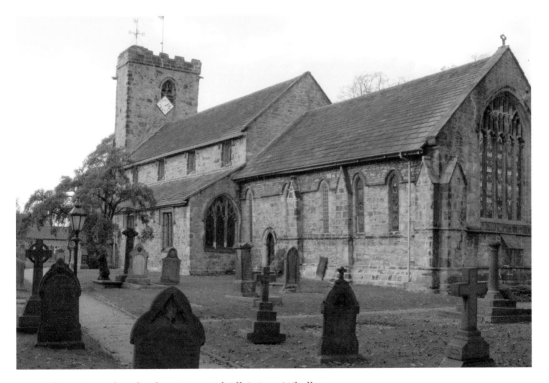

The ancient church of St Mary and All Saints, Whalley.

the ministers at the chapels were not entitled to call themselves vicar, they were parsons and that explains why in Newchurch and Burnley, for example, there are names associated with that title.

There has been a lot of speculation about what the name Whalley means. Some have thought that it derives from the number of sources of water and wells in the village but, splitting the name up into its two syllables, the most likely meaning is 'the clearing, or low lying meadow, below the round hill'. The place is very ancient and may have been the site of a Roman camp. The parish church, now dedicated to St Mary and All Saints, may have been founded as early at the end of the sixth century, though this cannot be proved. What is certain is that there was a parochial church in Whalley at a very early date. The existence of the three famous Celtic crosses in the churchyard supports this and we do know that, in Anglo-Saxon times, Whalley was governed by a hereditary Dean who was not in Holy Orders but charged with the management of the extensive parish because it was so remote from its bishop in Lichfield.

At the time of the Domesday Book (1086), Whalley church was known as 'the white church under the hill', but there is almost nothing remaining of this building save the doorway into the church from the south porch. In 1249, the last of the Deans died and Peter de Cestria (Peter of Chester) succeeded him as the first and only rector. Since then, Whalley has had a succession of vicars. The present church dates from the time of Peter of Chester when the Early English style was the norm, but there is quite a lot of Perpendicular work, the tower dating from around 1440. In fact, when the foundations were put in for the present tower, large blocks of masonry were found at a depth of 4 feet. These are supposed to have been part of an earlier Roman building. Though interesting externally, especially in its setting, it is the interior of the church that grabs the attention. The great east window with its magnificent heraldic shields was inserted in 1816,

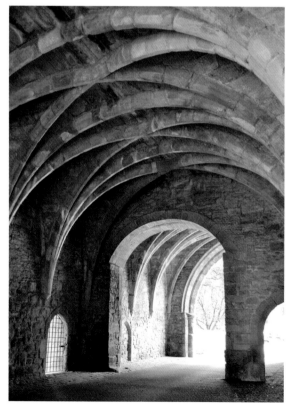

The Western Gateway of Whalley Abbey.

in the time when Dr Whitaker was the vicar. The shields are in five rows, representing either families or great offices of the church that can be associated with the original parish of Whalley. The Archbishops of Canterbury, who had the right of presentation from the Reformation, are represented in the top row by the arms of Charles Manners Sutton, who was Archbishop from 1805 to 1828. Also at the top are the arms of the Abbey of Whalley, Henry de Lacy, Earl of Lincoln (and Lord of Blackburnshire in the Middle Ages), the Duchess of Buccleugh (representative of the Lordship at a later time) and the Curzons of Whalley Abbey. In the second row you will find the arms of Towneley of Towneley and Dr Whitaker has not forgotten to place his own arms in the window. When you see the window, look for the arms of the families mentioned during our tour of the Lancashire Calder.

The church also contains a fifteenth-century chancel screen, the Catterall Brass and several monuments, one of which is believed to be that of Peter de Cestria who was incumbent from 1235 to 1295. Another monument in the chancel is to Dr Whitaker, the historian, who was vicar of Whalley from 1809 to 1822. The Kage is the family pew of the Nowells of Read. It dates from 1534 and was intended not to be a pew but the equivalent of a small private chapel. It is certain that the Nowell Kage was familiar to the members of the family we have met in these pages. The Medieval Pew was placed in the church by Sir John Towneley in his right as Lord of the Manor of Hapton. It was this Sir John who rescued the medieval altar vestments from Whalley Abbey, which are now one of the great treasures of Towneley Hall in Burnley. On the other hand, Sir John was reviled in Hapton itself because, in enclosing the land for his own purposes, he exiled families who had lived in the township for generations.

The choir stalls of Whalley church are among the most interesting in the country. They came from Whalley Abbey after the Suppression, and it has been said that they constitute the church's most beautiful possession. A date of 1430 has been ascribed to them and they were made by the abbey wood carver, who was called Eatough.

Visitors are invited to examine the misericords, the carved seats, which were used by the monks when they were attending services in the great abbey church. When turned up, the misericords reveal the most interesting carvings. They are all wonderful, but two are of particular interest. The first is of a warrior being beaten by his wife, who looks to be quite useful with a ladle, but the one to look for depicts an attempt to shoe a goose. It is accompanied by the following words, 'Who so melles hy(m) of y al me(n) dos cu(m) heir and shoe ye ghos', which means that meddling in other people's affairs never succeeds. Also, note the charming depictions of a blacksmith's workshop with anvil, bellows and other tools.

It is but a short walk to Whalley Abbey, which was a Cistercian foundation. Most properties of this Order were founded in the twelfth century, but the buildings at Whalley date from the end of the thirteenth century, though most of them are from the fourteenth. This is because Whalley is an example of a religious house that moved, in this case successfully, to a new site. Originally, Whalley was founded in 1178 at Stanlow in Cheshire. The move to Whalley was mooted just over 100 years later when the site at Stanlow, located on the south-west shore of the Mersey estuary, was very badly flooded.

Accounts differ about what happened next. It is likely that some monks made the journey to Whalley but no building work took place at the new site until after the death of Peter de Cestria in 1295. The abbey was therefore constructed in the same Early English style that had been adopted by the parish church. By all accounts, the arrival of the monks was not welcomed by all. There was a dispute about the proximity of the proposed abbey to the existing Cistercian house at nearby Salley (Sawley). This took time to resolve and the monks, having property near Liverpool, contemplated returning to Merseyside.

Fortunately, that did not happen and the building work at Whalley commenced. However, the oldest part of the abbey, the Oratory of Peter de Cestria, predates the monks. Though in ruins, this is still standing and is part of what is now known as the Conference House, formerly the much altered Abbot's Lodging (or House). Almost all the site is owned by the Diocese of Blackburn,

though the largest remaining building, the Lay Brethren's Dorter, is in the hands of the Roman Catholic church of the English Martyrs, which is on the Sands, just below the abbey precinct.

Only the foundations of the abbey church remain. Originally, the church was 260 feet in length, which compares favourably with the length of Ripon Cathedral at 270 feet. Manchester Cathedral is only 220 feet long but is disproportionately wide at 114 feet. Compared to York Minster, which is almost 500 feet long and 200 feet across the transepts, Whalley was not all that big but the reconstruction in the visitor centre at the abbey shows it was very impressive.

The more significant remains include the buildings near the cloisters, the octagonal chapter house, the reredorter, the later kitchens and the inner and western gatehouses. The inner, or north-east, gatehouse contains a small shop, a very good tea room and an exhibition area. However, in the village of Whalley, there are a number of buildings that have connections with the abbey.

Prime among them is the abbey corn mill, which though of a much later date, has become living accommodation. The corn mill was turned by water and, to ensure a ready supply, the monks constructed a large weir on the Calder possibly 600 years ago. This still survives, and exciting plans have been published to construct the Whalley Community Hydro, a renewable energy scheme, on the site.

There is much to see and do in Whalley. The site of the abbey fishponds can still be seen at Poole End. The former grammar school building, the Adam Cottam Armshouses, the site of the medieval manor house, and its replacement, remain sites worth exploring. It is, however, the Calder, now a broad and deep river, that dominates the village. Though Whalley itself purports to be in Ribble Valley, nothing is further from the truth. Whalley is a little bit of Lancashire's Calderdale that has been temporally surrendered to the Ribble Valley, just as the Calder itself, in the lovely pastures below Whalley, surrenders to the all embracing waters of the Ribble at Hacking.

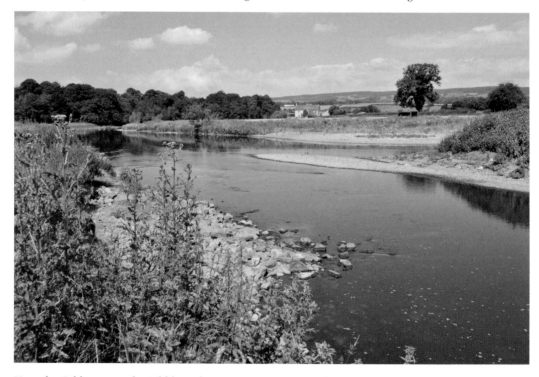

Here the Calder meets the Ribble and our journey is at an end.